Magic Lantern Guides

MINOLTA

CLASSIC CAMERAS

MAXXUM™

7000 9000 7000i 8000i

SRT SERIES · XD 11

Robert E. Mayer

Magic Lantern Guide to
Minolta Classic Cameras

A Laterna magica® book

Second Edition 1997
Published in the United States of America by

Silver Pixel Press
Division of
The Saunders Group
21 Jet View Drive
Rochester, NY 14624

Written by Robert E. Mayer
Edited by Ann H. Stevens
Layout: Buch & Grafik Design, Munich

Printed in Germany by Kösel GmbH, Kempten

ISBN 1-883403-17-0

®Laterna magica is a registered trademark of
Verlag Laterna magica GmbH & Co. KG, Munich, Germany
under license to The Saunders Group, Rochester, NY U.S.A.

Product photos supplied by
Michael Dierdorff of KEH Camera Brokers, Atlanta, Georgia,
Laterna magica, Minolta Corporation USA, Minolta GmbH,
and the author.

®Dynax, Maxxum, Minolta, and Rokkor are registered
trademarks of Minolta Corporation.

Contents

Dedication

This book could not have been completed successfully without the help of a number of individuals whom I want to thank sincerely.

First and foremost, I thank my wife of over 40 years, Grace, who quietly put up with the long hours consumed in researching and writing this book. Grace also proofread the entire text and assisted immensely in helping correct my grammar, spelling, and punctuation. Without her assistance, this book would not be very readable.

Thanks to my many friends at Minolta, especially Phil Bradon and John Jonny, who not only supplied me with sample cameras and other equipment to test and use, but also provided instruction books, literature, and many Minolta product photographs to help illustrate the book.

Thanks also to KEH Camera Brokers in Atlanta for providing samples of older equipment to photograph as illustrations of how to use the various Minolta cameras, and to Michael Dierdorff of KEH who made the actual photographs.

Thanks are due to public relations personnel at Agfa, Fuji, Ilford, Kodak, Konica, and Polaroid for providing samples of their various 35mm films, which were used to make the illustrations showing various lighting and flash techniques, and other typical photographic subjects. Accu-Color Lab, Inc., of Fort Wayne, Indiana, did most of the processing of my color transparencies, and A-1 Hour Photo, of Warsaw, Indiana, processed and printed much of the color negative film and the Ilford XP-2 film used to photograph the older cameras.

All in all, the experience of writing my first complete book has been both a challenge and a humbling experience. I hope I have provided ample quantities of useful information and reference data that will assist those of you currently using the older models of Minolta classic cameras. Here's to good shooting with these capable products for years to come.

Introduction

Minolta Camera Co., Ltd. was founded in Osaka, Japan, in 1928. In Japanese, the word Minolta means "ripening rice fields." The surrounding countryside has inspired names for various Minolta products, such as Rokkor lenses, named for the majestic Rokko mountain near Osaka.

The first Minolta camera was introduced in 1929—a small, folding 120 film model called the Nifcalette. Seven years later Minolta announced the first of many "firsts": the Minoltaflex, Japan's first twin lens reflex camera. Other firsts soon followed, which had an impact on regional and global markets. By 1942, Minolta had established their first glass melting works to manufacture optical glass. In 1950 the first 16mm pocket camera was put into production, and in 1958 Minolta introduced the SR-2, their first SLR (Single Lens Reflex) camera with a bayonet lens mount system. During the 1950s, Minolta also developed the first Japanese-made planetarium projector. The SR-7 35mm SLR of 1962 was the world's first still camera with a built-in cadmium sulfide (CdS) exposure meter. Also in 1962, a Minolta Hi-Matic rangefinder 35mm camera went along on America's first spaceship, the Friendship 7.

In 1968 when Apollo 8 orbited the moon, a Minolta Space Meter was on board. Minolta introduced its revolutionary 110 Zoom SLR in 1976. It was the first 110 cartridge camera with SLR viewing, a 2x zoom lens, and automatic exposure control with manual override. That same year, Minolta also announced the new XD-11, the world's first multi-mode 35mm compact SLR system camera.

Note: Throughout the text, left and right are used to identify the positioning of various buttons, symbols, and controls on the cameras. These terms refer to the camera when it is held in the shooting position.

Guide to the Classics

Although there is no end to the choices of SLR cameras currently on the market, many of you may own, inherit, or purchase an older model that suits you very well. Most likely these classic cameras are missing their original instruction manuals, and perhaps you would like to know what a certain mysterious button does. This book seeks to satisfy that need, acting as a worthy companion by offering tips on how to get the most out of your classic Minolta SLR camera. It covers operating instructions, lenses, accessories, picture-taking hints, and the compatibility of various accessories. We hope that it will help you get the most out of your camera.

This book includes the more well-known Minolta classics. The SR-T 101 is used as an archetype for examining the complete SR-T series. The XD-11 and several Minolta Maxxum (called "Dynax" in countries outside North America) autofocus SLRs are also covered. Of the Maxxum series, the Maxxum 7000 and 9000 cameras and two second-generation Maxxum 7000i and 8000i cameras are featured.

Since the introduction of the first Maxxum camera in January 1985, Minolta has released a new model at least every two years. These have incorporated new features and improvements to the extent that some models have inaugurated an entirely new Maxxum series. While not every photographer has traded in their earlier camera for the latest model with enhanced features, many do own several different generations of Maxxum bodies along with a variety of lenses and other accessories. Because compatibility information is so important, this manual provides a guide to working with the wide range of vintage Maxxum accessory equipment. We hope it proves useful to you in your picture-making endeavors.

Why Choose a Manual SLR Camera?

Practically all of the hundreds of cameras available today are designed and pre-programmed to produce good pictures with minimal knowledge or expertise from the photographer. You simply point the camera at the subject, compose the picture in the viewfinder, and push the button. The image is recorded instantly; there is no need to make calculations or change settings if you want to shoot quickly. So why choose a manual SLR? One reason is that while these automatic, electronic features are seductive,

the price of automation is costly. A fully manual SLR can be purchased for much less than many of the fully automatic point-and-shoot cameras.

The more compelling reason for selecting a manual SLR is that it allows the photographer to have direct control over the basic variables involved in picture-taking—focus, exposure, depth of field, shutter speed, and lens type—giving the photographer greater control over the final image. Understanding how each function affects the image can make photography a more rewarding experience.

Why Choose an Autoexposure, Autofocus SLR Camera?

Once you appreciate the benefits of SLR technology and have a fairly good understanding of basic camera functions, you may wish to own an SLR camera that offers both automatic and manual exposure and focusing capabilities.

Setting a camera on an autoexposure mode takes some of the guesswork away from the photographer. The camera's electronics automatically prescribe shutter speed, aperture size, or both, depending on the specific mode you select. With practice, you'll soon learn when a faster shutter speed or smaller aperture is desirable and which mode is appropriate to achieve the desired effect. You will recognize situations when the camera's pre-programmed operation does not select the settings that seem right for a particular subject. In this case, autoexposure cameras allow you to intervene and take control by simply changing programs or switching to fully manual operation.

SLRs with autofocus offer the photographer the ease of taking photos quickly at times when fussing with focus could result in missed opportunities at family outings or sporting events. But AF SLRs do not relinquish total control to the camera's electronics. Manual focusing is still possible for those few subjects that frustrate the AF sensors, such as nighttime skylines, parallel patterns or bars (as are often found at the zoo), pictures taken through windows, and some low-contrast subjects, such as a plain wall without any distinct vertical or horizontal pattern.

The beauty of these AE, AF SLR cameras is that they offer the best of both worlds: automatic *and* manual features, giving you the widest range of flexibility and control without being a slave to the automation.

Minolta SR-T Series

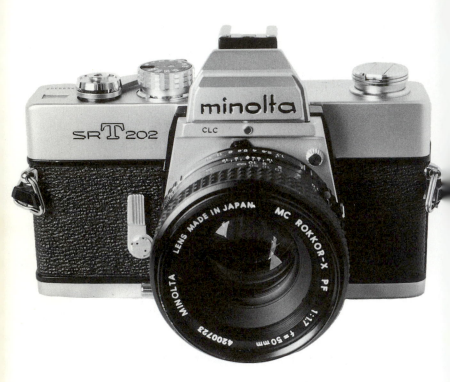

The SR-T series was developed in an era when SLR cameras were basic picture-making machines. They were the first Minolta Single Lens Reflex (SLR) cameras to offer full-aperture, Through-the-Lens (TTL) metering. More than three million of six different SR-T models were produced from 1966 to 1981. These include the SR-T 100, SR-T 101, SR-T 102, SR-T 201, and SR-T 202 (designated as the SR-T 303 in countries other than the USA).

These cameras had a strong reputation for precision and durability combined with reliable mechanical performance. The success of the SR-T series helped to position Minolta as a "major player" in the competitive 35mm camera market. Even today, many photographers still use these venerable Minolta SLRs.

Minolta SR-T 101

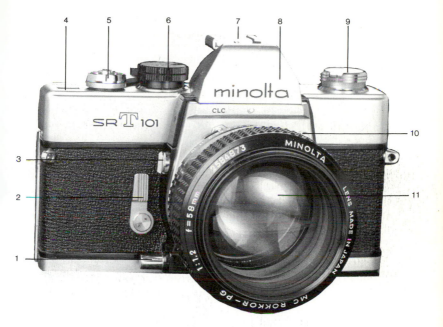

1	Aperture stop-down button	7	Accessory shoe
2	Self-timer lever	8	Pentaprism
3	Mirror lock-up button	9	Film rewind crank/back
4	Frame counter		cover release knob
5	Shutter release button	10	Lens release button
6	Shutter speed and ASA (ISO)	11	Rokkor lens
	film speed dial		

Important Features

The viewfinder in the SR-T 101 provides valuable information to assist the photographer. The shutter speed setting is visible at the bottom. At right is a "follow-up" needle (with a circular indicator) coupled to the lens aperture, which aligns with the meter indicator needle to verify accurate exposure settings. In addition, the

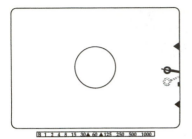

The SR-T's viewfinder displays the shutter speed at the bottom. The camera's recommended exposure has been set when the straight needle aligns with the circular "follow-up" needle. The small rectangle at right is the battery-check indicator.

viewfinder has a battery-check indicator that reveals the battery's status at a glance.

Minolta claimed the reflex mirror deflecting the lens image into the prism was the largest of any SLR produced at the time. This feature minimizes mirror cut-off (darkening of the upper part of the viewfinder), which typically occurs with super telephoto lenses or in ultra close-up photography.

The camera also features a dual-cell Contrast Light Compensation (CLC) exposure metering system. At the time the camera was introduced, Minolta claimed that the two cadmium sulfide (CdS) metering cells at the top of the pentaprism compensated for high-contrast light, which had typically caused problems for earlier built-in metering systems.

In addition, the camera features full-aperture metering, a far easier method of determining exposure than the stop-down metering system that was common in most other brands. The major advantage of full-aperture metering is that the photographer can compose and meter at the maximum (widest) lens aperture. Hence, the viewfinder remains bright for a clear view of the subject.

The camera accepts a 1.35v button-type mercury battery, which provides power for the camera's built-in light meter. The cover of the battery compartment is easily removed with a coin or by pressing your thumb against it while turning, depending on the SR-T model. The battery is then placed into the battery compartment in the bottom of the camera with the plus (+) side facing out. At the other end of the bottom plate is a smaller, knurled button labeled "B.C." (Battery Check), "OFF," and "ON." When you turn this switch to "B.C." the indicator needle in the camera's viewfinder will point at the battery-check symbol (the small rectangular box protruding into the screen on the right) if the battery is functioning properly.

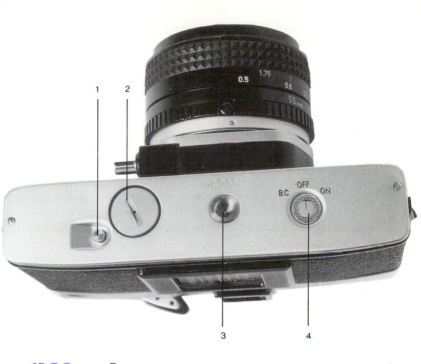

SR-T Camera Base

1	Film rewind button	3	Tripod socket
2	Battery cover	4	Battery switch

Note: At the time this book was written, the 1.35v mercury batteries originally used in the SR-T series cameras were becoming nearly impossible to locate in many states due to government and state bans on disposable products containing mercury.

Wein Products, a leading manufacturer of photo slaves and flash accessories, has developed a solution to the problem with the introduction of the WeinCell (MRB-625), a 1.35v replacement battery. The zinc-air composition of the WeinCell delivers an extremely stable output that rivals the original mercury cell. At present, the WeinCell is the only known exact-voltage replacement for the PX-625/PX-13 and is available through The Saunders Group.

Similar-sized alkaline batteries are available (such as the Duracell PX-625A) and can be used, however they produce 1.5v instead

of the 1.35v required for these cameras. As these alkaline batteries age, their voltage fall-off differs from that of the original battery, leading to erratic meter readings. If you must use the 1.5v battery, we suggest you verify your readings with a hand-held meter.

Using the SR-T 101

Loading and Unloading the Film

Open the camera back by pulling up on the back cover release knob until the back cover pops open. When this occurs, the film counter automatically resets to the Start ("S") position. Place the film cassette, protruding end down, into the film chamber on the left, and push the back cover release knob down. Pull the film leader across and insert it into one of the four slots in the film take-up spool on the right.

Now operate the film advance lever in several short strokes until the film has begun to wind firmly around the camera's film take-up spool. Make sure that the perforations on both sides of the film are engaged with the teeth of the sprocket gear. If the film advance lever should lock while winding, press the shutter release button and continue. Gently rotate the film rewind crank on the left to take up any slack in the film so it lies flat against the pressure plate. Close the camera back and advance the film until "1" appears at the arrow in the frame counter window.

Note: Nothing is more disappointing than getting a blank roll of film back from the processing lab when you thought you had shot the full roll! The main reason this can happen is that the frame counter on the SR-T series cameras advances whether film is actually being transported or not. The only sure way to tell if the film is advancing properly is to watch the rewind knob as you wind the film. After loading the film and advancing to frame "1," lift the rewind crank and gently wind it in the direction of the arrow to remove any extra slack inside the camera. Once you have done this, the rewind knob will always turn in a counterclockwise direction each time the film is wound, alerting you that the film is advancing as expected.

The film advance lever can be operated in one continuous stroke or ratcheted in several shorter strokes. It has a total throw of 170°, but the first 20° of the stroke has no effect on the film. This allows the advance lever to be offset from the body, keeping it accessible for rapid shooting.

The ASA film speed (now termed ISO, but using identical numbers) must be set. Lift up on the knurled knob surrounding the shutter speed dial on the top right of the camera; turn it until the number corresponding to the film's ISO is visible in the window labeled "ASA."

To rewind a roll of exposed film, first depress the film rewind button on the bottom of the camera. It should remain depressed even when you remove your finger. Now gently flip up the film rewind crank on the cover release knob and turn it clockwise (in the direction indicated by the arrow). When you feel a slight resistance, the film will be almost entirely rewound and detached from the take-up spool. After one or two additional turns of the rewind crank (you should feel less tension on the film) you can assume the film has been fully rewound into the cassette. Now it is safe to open the back by lifting up the back cover release/film rewind knob assembly and remove the film.

Hint: Older cameras like the SR-T 101 do not have a window in the back to indicate that film is loaded. Therefore, if you are unsure about whether or not you should open the camera's back, it is a good idea to first turn the film rewind crank gently several times in the direction of the arrow before opening it. If film is loaded, you will quickly notice a resistance and the knob will not turn any further. This old technique can prevent you from accidentally fogging the film.

Exposure Controls

Making TTL meter readings with Rokkor MC lenses is simple. When you aim the camera at the intended subject, the meter indicator needle on the right side of the viewfinder moves. When it stops, turn either the shutter speed dial or the lens aperture ring to align it with the circular follow-up needle. The shutter speed setting will be indicated by a set of arrows on the bottom of the viewfinder outside the picture area, so you can adjust the speed without removing the camera from your eye.

Hint: It is easiest and least awkward if you set the shutter speed first, then adjust the lens aperture. If the indicator needle does not move when the lens diaphragm ring is rotated, you'll need to adjust the shutter speed further.

Caution: Never try to set the shutter speed dial between the click stop speeds. It functions only in full-step increments. For more critical exposure settings, the lens aperture ring can be set at either full- or half-stop detents.

The shutter speed dial is marked in speeds from 1 to 1/1000 second and "B," the Bulb setting. In the "B" setting, the shutter will remain open as long as the shutter release is depressed (use of a locking cable release is recommended). The meter will not function when set at "B." The speed of "60" (1/60 second) is marked in red to indicate the maximum or fastest shutter speed for proper electronic flash synchronization for this camera. Any speed from 1/60 second to one full second or "B" can be used with electronic flash, but 1/60 is recommended. Shutter speeds faster than 1/60 second cannot be used with flash. This causes improper flash synchronization resulting in only a partial exposure of the film frame because the focal-plane shutter is not completely open when the flash fires.

Focusing

Visual aids located in the center of the viewing screen assist you in focusing the camera. If an image is out of focus, the center spot microprism area will "shimmer." As the image is focused, it becomes clearer.

Basic Flash Operation

The SR-T 101 has two options for connecting a flash—a hot shoe on the pentaprism and a PC cord terminal on the front of the camera body, to the left of the lens. If you are using a flash unit with a hot shoe contact, a PC cord is unnecessary.

Some SR-T camera models (the SR-T 101 included) have two PC terminals: one labeled "X" for electronic flash, the other labeled "FP" for older, focal-plane flashbulbs. Other SR-T cameras have only one PC cord terminal and a movable switch to select either X or FP synchronization. Because flashbulbs take a moment to attain maximum brilliance after ignition, the SR-T's FP terminal allows the flash to trigger a bit early to assure that the bulb is burning at its brightest when the shutter actually opens. For electronic flash, you *must* use the X terminal or setting. Because electronic flashes are at peak brilliance immediately when triggered, the flash fires right as the shutter starts to open. X sync synchronizes the shutter's opening with the flash firing.

Mirror Lock-Up

1 Mirror lock-up button
2 Self-timer lever
3 Aperture stop-down button

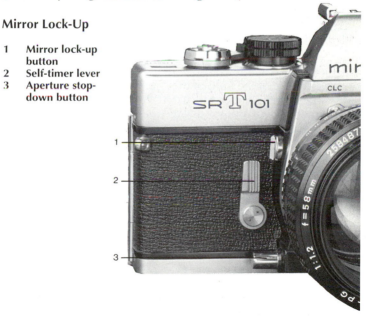

When a picture is taken, the reflex mirror swings up out of the way so that light is no longer diverted through the prism finder

but instead, strikes the film. This movement of the mirror, or "slap," creates vibration in any SLR camera. Older cameras, however, had less cushioning than today's SLRs. Fortunately Minolta solved this problem in the SR-T 101 by providing mirror lock-up capability. The mirror lock-up should be used with a microscope attachment, a macro lens, or any time you use a slow shutter speed. For conventional picture-taking you will not need this feature, but we do recommend using it for high magnification photography or long exposures, preferably tripping the shutter with a cable release. The mirror lock-up is also necessary when using the ultra wide-angle Rokkor 21mm lens. Because its long rear element extends into the mirror chamber of the camera, the mirror must be locked up out of the way.

To operate the mirror lock-up, turn the small round button to the right side of the lens mount, clockwise until it stops. (This button must be returned manually to its original position, indicated by a small red mark, for standard operation.) This feature operates independently of the shutter release and can be activated at any time. Please note that the camera's exposure meter is inoperative with the mirror locked up.

Self-Timer
On the right side of the front of the camera is a lever that activates the self-timer mechanism. To use it, first move the lever down about 90°, then press the tiny self-timer release button that has been exposed. (The release button is hidden under the lever when it is in the vertical ["OFF"] position.) The self-timer will now start to operate. In about ten seconds, the camera shutter will trip automatically.

Note: The self-timer cannot be activated unless the film has been advanced and the shutter cocked. The self-timer can be overridden by pushing the shutter release button either before or after the self-timer release button has been pressed.

Using MC Rokkor Lenses

Nearly 40 different MC (Meter Coupled) Rokkor lenses, ranging from a 7.5mm f/4 fish-eye to a 600mm f/5.6 super telephoto, were offered for the SR-T 101. MC lenses were offered in three versions: early Rokkors with metal focusing rings; Rokkor-X lenses with rubberized inserts to aid in focusing; and MC Celtic lenses, the economy models. Later model MD Rokkor lenses (designed for automatic use with the XD-11 and XD-5 cameras) can also be used on the SR-T series of cameras.

To remove a lens from the camera, press downward on the small, knurled, lens release button just above and to the left of the lens. Rotate the lens counterclockwise until it stops, and then pull it straight out. To attach a lens, first align the red dots on the lens and body, then turn the lens clockwise until you hear it lock into place.

Each MC Rokkor lens has a depth-of-field scale in front of the white diamond index mark used to indicate both the lens aperture and distance. You can pre-calculate the actual range of acceptably sharp focus at any f/stop by referring to this scale.

MC Rokkor lenses are designed with full-aperture metering capabilities so that the photographer can compose at the widest aperture, which offers the brightest possible viewfinder image. (When you press the shutter release, the diaphragm automatically stops down to the selected aperture). There are times when you may want to view the scene at a smaller aperture to visualize the depth of field. To do so, simply depress the long, stop-down button at the bottom right of the lens mount, and the lens will close down to the set aperture. The lens will remain stopped-down until the button is pressed again. After taking a picture, it automatically reopens to its widest aperture.

The lens release button is the small, knurled button just above the lens.

Using Auto Preset Lenses

For older Rokkor (and other manufacturers') lenses, you must use the stop-down method of TTL metering. To do this, first advance the film. Next push in the stop-down button, set the desired shutter speed, and turn the aperture ring on the lens until the two needles align. You can take the picture with the lens stopped down or press the stop-down button again to open the lens for brighter viewing. When the shutter is released, the diaphragm automatically closes down to the preset aperture to make the picture and then reopens. This method of metering is a bit tedious, but it allows you to use many older lenses made by Minolta or other manufacturers.

You can also use manual, preset Rokkor (and other) lenses without using the camera's aperture stop-down button. These lenses have a manual ring that can be set for the desired lens aperture, then quickly opened for focusing, and manually reset to the stopped-down setting just before exposure.

SR-T Accessories

Many accessories were offered for the SR-T series of SLRs. They include an angle finder, magnifier, eyepiece correction lenses, close-up lenses, filters, extension bellows, extension tube sets, copying stand, microscope adapter, photo-oscilloscope adapter, panorama head, and a folding flash gun for then-common, peanut-size flashbulbs.

All MC Rokkor lenses accept standard threaded filters. These improve the rendition of the scene on film. Special-effect filters such as those manufactured by Cokin® are available at most photo retailers carrying Minolta cameras.

Minolta SR-T 101 Specifications

Type: 35mm SLR with TTL exposure meter.

Standard Lens: 58mm f/1.4 equipped with meter coupler.

Lens Mount: Minolta SR bayonet mount.

Metering: TTL meter; contrast light compensator, CdS meter, two cells on the pentaprism.

Exposure Range: EV 3 to EV 17 with ISO 100 film, 58mm f/1.4 lens.

Flash Sync: FP and X sync (up to 1/60 second).

Exposure Controls: Depth-of-field preview button for MC Rokkor lenses; measuring (stop-down) button for other automatic Rokkor lenses.

Shutter: Focal plane shutter; speed range from 1 to 1/1000 second plus "B."

Film Speed Range: ASA (ISO) 6 to 6400.

Film Transport: Lever-type; quick-advance winding with shutter cocking and double exposure prevention.

Viewfinder: Eye-level fixed pentaprism; life-size image viewing with 58mm lens on infinity; viewing area 33.7 x 22.4 mm.

Viewfinder Display: Exposure control needles and shutter speed scale.

Power: 1.35v, PX-625, or WeinCell MRB-625 or equivalent; battery-check symbol in viewfinder.

Dimensions: 5-3/4 x 3-1/2 x 3-3/4 in. (145 x 89 x 94.5 mm) with 58mm f/1.4 lens.

Weight: 35 oz. (990 g) with 50mm f/1.4 lens.

Minolta SR-T SLR Model Feature Comparison

Model	SR-T 100	SR-T 101	SR-T 102
Introduced	1971	1967	1973
Top Shutter Speed	1/500	1/1000	1/1000
Self-Timer	No	Yes	Yes
Sync Terminals	X+FP	X+FP	X/FP Switch
Hot Shoe	No	No, Later Model X-Only	FP/X Sync
Depth-of-Field Preview	Lockable	Lockable	Lockable
Multiple Exposure	No	No	Yes
Mirror Lock-up	No	Yes	Yes, on Early Model
Memo Holder	No	No	Yes
Safe Load Signal	No	No	No
Focusing Screen	Micro Prism	Micro Prism	Split Micro
VF Speed	No	Yes	Yes
VF Aperture	No	No	Yes

SR-T 200	SR-T 201	SR-T 202
1975	1971	1975
1/1000	1/1000	1/1000
No	Yes	Yes
X+FP, Later Model X-Only	X+FP, Later Model X-Only	X/FP switch, Later Model X-Only
No, Later Model X-Only	X Sync	FP/X Sync
Not Lockable	Not Lockable	Not Lockable
No	No	Yes
No	No	No
No	Yes	Yes
No	No	Yes
Micro Prism, Later Split Micro	Micro Prism, Later Split Micro	Split Micro
No	Yes	Yes
No	No	Yes

Minolta XD-11

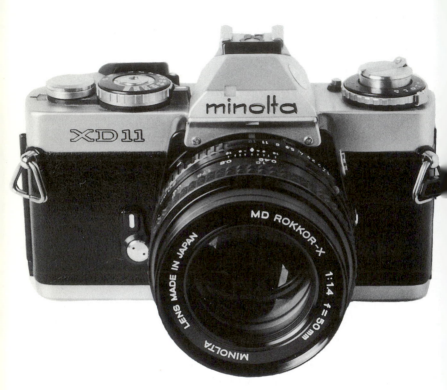

Ask a group of knowledgeable photographers, photo retailers, or even the technical experts at Minolta what they consider to be *the* classic Minolta camera, and many will select the XD-11, a truly unique camera for its era. (It was marketed as the XD-7 in Europe and as the XD in Japan.) Introduced in 1977, eight years before the first autofocus Maxxum camera, this SLR was ahead of its time. Small, lightweight, and full-featured, the XD-11 offers everything a photographer could want in a modern, interchangeable-lens, non-autofocus SLR camera. The XD-5 was nearly identical to the XD-11, lacking only two of its viewing features in AE modes.

Important Features

The XD-11 was the first multi-mode, autoexposure SLR camera. It featured new, electronic-based AE technologies, such as Aperture and Shutter Priority autoexposure modes as well as Metered Manual mode, common in today's cameras.

In the two semi-automatic (Aperture or Shutter Priority) modes, you set either the lens aperture or shutter speed, and the camera's computer automatically and steplessly controls the other value for proper exposure. The full-information viewfinder with LED indicators on the right side also has small windows at the bottom that conveniently display both the shutter speed and lens aperture. This feature is common in today's cameras, but was unique at the time when this SLR was introduced. A "safe load" signal and a smooth electromagnetic shutter release complete the list of this camera's primary virtues.

Minolta refers to the Silicon Photo Diode (SPD) metering of the XD-11 as "final check" metering. This can be translated as follows: In any mode, the light for the actual exposure is metered with the lens stopped down to the actual set aperture just before the shutter opens to record the image. If there is too much or too little light for proper exposure, the internal electronics automatically alter the shutter speed to produce the proper exposure. This safety feature does not function in Manual mode, however. In Manual, the f/stop and shutter speed set by the photographer are used for the photo.

An eyepiece shutter lever is located on the camera's back, to the left of the viewfinder. Whenever you are taking a picture and your eye is not against the viewfinder (such as when tripping the shutter remotely or with the self-timer), you can cover the eyepiece, otherwise light entering can cause erroneous exposure.

The XD-11 has other useful features as well. A safe load signal monitors film alignment and advance. You can make multiple exposures without the frame counter advancing. An exposure compensation index allows you to compensate up to two stops in either direction (intentionally over- or underexposing from the metered value). It has a self-timer that can be used in either auto or manual exposure. Finally, on the back of the body you'll find a handy ASA/DIN (now termed ISO) conversion scale and a memo holder into which you can slip the end flap from a box of film to identify the film that is loaded.

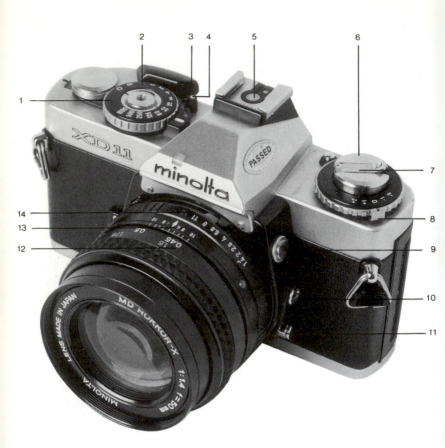

1	Shutter speed selector	9	Lens release button
2	Shutter release	10	PC terminal
3	Film advance lever	11	Stop-down button
4	Mode selector switch	12	Distance scale
5	Hot shoe	13	Depth-of-field scale
6	Back cover release knob	14	Aperture ring
7	Film rewind crank		
8	Exposure compensation control		

Using the XD-11

Loading and Unloading the Film

Loading the XD-11 follows standard procedure for cameras of this era. First, pull the film rewind knob on the top left of the camera up until the back springs open. With the knob in the "out" position, place a film cassette in the film chamber with the projecting end of the spool pointing downward. Push the rewind knob back in all the way. It may be necessary to rotate the knob slightly in order to align the slot with the cassette's spool.

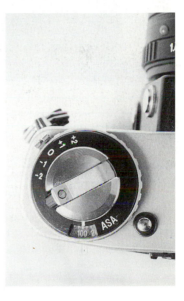

Pull out the end of the film leader and bend the end slightly so that it fits under one of the several slots in the bottom of the take-up spool on the right. Be sure that the tooth on the slot is engaged with one sprocket hole near the end of the leader. The end of the leader *should not project* from the slots on the take-up spool, as the film may not wind smoothly.

Advance the film slowly until it begins to wind firmly around the take-up spool and the sprocket teeth are engaged with the holes on *both* edges of the film (i.e., top and bottom). If the film advance lever should happen to stop at the end of a full stroke during this initial procedure, just press the shutter release button and continue to wind until the leader is wound onto the take-up spool and two sprocket teeth are engaged.

How to Load the Film

Now close the camera back and push it until you hear a "click" confirming that it is locked. A red "S" should appear in the frame counter window on the right shoulder of the body. Advance the film and trip the shutter until the index points to "1" on the frame-counter dial. Two or three full winds are adequate to advance the

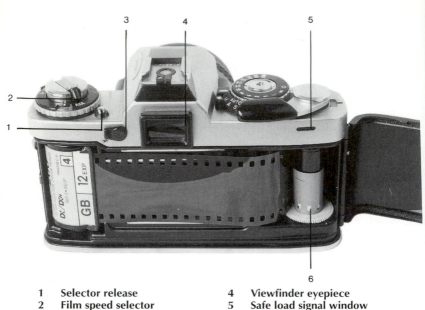

1	Selector release	4	Viewfinder eyepiece
2	Film speed selector	5	Safe load signal window
3	Eyepiece shutter lever	6	Take-up spool

film past the portion of film leader that was exposed while load-ing the camera.

A red bar should appear at the extreme left end of the narrow safe load signal window just below the film advance lever. This signal indicates that the film is loaded and winding properly onto the take-up spool.

Caution: If the safe load signal does not appear, repeat the load-ing procedure by opening the camera back and reattaching the end of the leader into one of the slots. As you take pictures on this roll of film, the red signal bar will move gradually toward the right of the window, indicating that the film is advancing correctly. This will be the only indication that the film is advancing. Do not rely on the frame counter, it will advance whether the film is loaded or not.

To advance the film, first pull the tip of the film advance lever from its "off" position (against the shutter speed dial) out until it

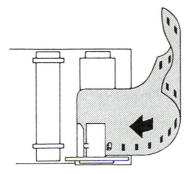

The above diagram shows the correct way to thread the film leader through the XD-11's take-up spool.

The procedure illustrated above is incorrect. Do not load the film this way!

rests slightly away from the body. By winding the lever in one long stroke until it stops (130°), the film advances to the next frame and the shutter cocks. Unlike some wind-lever SLRs, a full stroke motion must be used. You cannot ratchet the advance with several short strokes.

Every film has an ISO (once termed ASA) value, or film speed, and the camera must be set accordingly before you take any pictures. Surrounding the base of the back cover release knob is the ISO window and scale. It is marked with the old "ASA" indication, but the numbers are identical to today's ISO designations. Depress the small button to the right of this dial and turn the ring to set the correct ISO speed.

To rewind and unload the film, first depress the small film advance release button on the bottom right of the camera. Unfold the rewind crank found on the back cover release knob at the far left of the top of the camera and turn it clockwise (as indicated by the arrow) until the red safe load signal bar moves out of the window and the tension gives way. Pull the back cover release knob up. The back cover will release, and you can safely remove the film cartridge.

Note: Always load and unload the film in subdued light or shadow. If no shade is readily available, bend over the camera to shade it

with your body. Bright sunlight can leak into the cassette through the felt light trap. Especially with fast film (ISO 800 or higher), this could fog several inches of film inside.

Viewfinder Specifics

The viewfinder contains an acute-matte focusing screen, which produces a bright, contrasty, fine-grained focusing field usable in all light levels. In the center is a horizontal split-image focusing spot surrounded by a small donut-like fine focusing area. An over-sized reflex mirror makes image cutoff negligible even when the 1600mm RF Rokkor-X long telephoto lens is used.

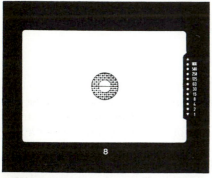

A Mode

S Mode

The full-information view-finder of the XD-11 gives the photographer essential information on camera set-tings. Top: In Aperture Pri-ority ("A") mode, the se-lected aperture is shown below the viewfinder im-age. The shutter speed se-lected by the camera is in-dicated by an LED on the right. Bottom: In Shutter Priority ("S") mode, the user-selected shutter speed and the aperture index set-ting (the lens' smallest aper-ture) are shown at the bot-tom of the finder while the aperture set by the camera is indicated by an LED on the right.

The LEDs along the right side of the viewfinder display a great deal of information. When in Shutter Priority mode, the aperture selection will be displayed. In Aperture Priority mode the shutter speed will be displayed, and in Manual mode the recommended shutter speed for "correct" exposure will be displayed. Triangular LED indicators, visible at the top and bottom of the scale, indicate that the aperture or shutter speed required for correct exposure is beyond the camera's range. Adjust the camera's exposure to bring it within range.

At the bottom of the viewfinder, outside the image area, are two small boxes—one for the aperture (f/stop) selected and the other for the shutter speed. Both boxes will display in Shutter Priority and Manual modes, however only the f/stop will appear at the base of the screen when in Aperture Priority mode.

Exposure Controls

The XD-11's extra-large shutter speed dial has positive detents at each of the shutter speeds marked on the dial. Shutter speeds available are the conventional range typically found in mechanical SLR cameras: 1 to 1/1000 second. There are three additional positions: a red "X" for the flash sync speed of 1/100 second, a "B" for Bulb (manually controlled exposures), and "0" (1/100 second combined with X sync).

The "0" and "B" settings are both mechanical settings; they can be used even when there is no battery in the camera body. This is a handy feature if the battery fails. In these two settings the electromagnetic shutter-release action (which requires batteries) does not function, and the shutter will function mechanically. There is no metering guidance; exposure can be controlled only by adjusting the aperture opening. Using the "0" position provides a fixed shutter speed of 1/100 second for synchronized exposure with electronic flash or existing light. Using "B" allows you to make an exposure that lasts as long as the shutter release is depressed.

The metal bladed, vertical-traveling focal-plane shutter is quiet in operation and exceptionally smooth due to the electromagnetic release button. However, some pictures require the security of remote shutter release (such as long exposures with a tripod or pictures of wildlife). For these situations, two accessory electronic

remote cords are available (Remote Cord RC-1000S [short] and RC-1000L [long]). These screw into the threaded cable release socket in the center of the shutter release button. Remote operation is possible at all speeds except "B." The shorter cord is 20 in. (50 cm) long, and the longer cord is 16-1/2 ft. (5 m) long. When used with the Auto Winder D, the RC-1000L can be used to make both single or continuous sequence exposures.

Setting Shutter Speeds and Apertures
Since the XD-11 is an electronic, fully automatic SLR, it provides precise exposure compensation, with changes made in minute (stepless) increments. You are not limited to full shutter speeds or half-stop lens apertures as with mechanical cameras of this vintage that required manual settings be made.

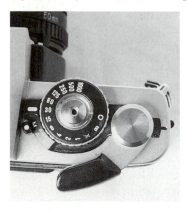

For knowledgeable photographers who can previsualize the end results desired in each picture, Aperture or Shutter Priority AE modes can be a real asset. They offer convenient operation while allowing you full control over the range of sharpness or the depiction of motion. The mode selector lever is found beside the shutter speed dial and can be switched to "M" (Manual), "A" (Aperture Priority AE), or "S" (Shutter Priority AE). The hard-to-move lever and positive detents make it nearly impossible to accidentally change this setting after you have selected the desired mode.

In Aperture Priority and Shutter Priority AE modes, the XD-11 will set the exact aperture or shutter speed needed for perfect exposure as determined by the camera's meter. If a shutter speed of 1/131 second or an aperture of f/7.42 is determined by the meter, that is what will be set. Admittedly, only less-forgiving color slide films really need such precision, but it is nice to know the capability is there. In Manual mode, you are limited to full shutter speeds and half-stops on lens aperture settings. In this respect, the XD-11 is the same as any fully manual camera.

Aperture Priority Autoexposure Mode

When should you select Aperture Priority AE mode? When you want to control the depth of field in your pictures. You might be photographing a vast landscape with foreground, middle-ground, and background elements. To achieve maximum sharpness in all three, set the lens for a small aperture such as f/11 or f/16. Conversely, for most portraits, a shallow depth of field is preferred to place emphasis on the primary subject's face, with a blurred background. For this application, select a wider aperture of f/2.8 or f/4.

Portraits lend themselves to using a shallow depth of field, which blurs the background and emphasizes the main subject, whether it be a friend or wildlife.

For Aperture Priority AE, first set the mode selector switch to the "A" position, and select the desired f/stop on the lens' aperture ring. The aperture value selected appears at the bottom of the viewfinder in a small box. The camera's electronics will automatically select the corresponding shutter speed for you, and it will be indicated by an LED beside the shutter speed scale on the right side of the viewfinder. The shutter speed dial can be left at any setting.

Shutter Priority Autoexposure Mode
Shutter Priority AE mode is typically selected for fast-action subjects. When you want an action-stopping shutter speed, select 1/500 second or faster to "freeze" the motion. This is useful in sports photography or anytime you are photographing a fast-moving subject. Naturally, depth of field will be shallow with the wide aperture that is usually required for such a short exposure time. In other cases, you might decide to purposely blur a moving subject, such as a waterfall, to produce the impression of motion. Select a slower shutter speed of 1/8 or 1/15 second. This will record a moving subject as a total blur. You can also follow the motion by panning the lens and tripping the shutter at the mid-point of the pan. The result will be a reasonably sharp subject against a blurred background, rendering a convincing impression of motion. In either instance, using Shutter Priority AE mode gives you complete control over the shutter speed to create the effect of motion on film.

Shutter Priority AE mode will work only with MD Rokkor lenses. To select Shutter Priority, move the mode selector switch to the "S" setting. This sets the camera's computer and displays the aperture (f/number) scale at the right side of the viewfinder. Now rotate the aperture ring on the lens so that the the largest f/number, called the aperture index setting, is aligned with the diamond index mark. The lens *must* be set to this number for "S" mode to work properly! The system will then choose the aperture opening required for correct exposure. The camera's computer will change the f/stop according to the light level or reflectance of the scene.

Turn the shutter speed dial to set any speed from 1000 (1/1000 second) to 1. The selected speed will appear slightly to the right below the frame in the viewfinder. The f/stop selected by the camera will be indicated in the center below the viewfinder when the

shutter release is depressed slightly. Assuming that the light does not change, the picture will be made at that f/stop. All that remains is to focus, compose your picture, and make the exposure.

In Shutter Priority AE mode, you may encounter situations when the required aperture is outside the range of those available on the lens in use (i.e., in extremely bright or dark conditions). If so, one of two red triangular LEDs will light up on the shutter speed scale on the right of the viewfinder. These triangles indicate over- or underexposure. When either triangle is lit, the camera will automatically compensate to avoid exposure error. It will change the shutter speed to one that corresponds to the system-selected aperture.

This safety feature is useful in autoexposure modes, but sometimes you will want full control. In that case, you must switch to Manual mode. This mode overrides the system's automatic exposure compensation, and you can adjust the shutter speed until an LED lights within the scale's range.

Caution: *If exposure conditions are entirely beyond the meter's range, the mirror will lock up when the shutter is released. If this occurs, move the shutter speed selector knob to "X," "B," or "O" and then back to its previous setting. This resets the mirror and returns the camera to full operation.*

Metered Manual Mode

For full control over all aspects of the exposure, simply move the mode selector switch beside the shutter speed dial to "M" (Manual). Now you can select any shutter speed and f/stop you want. The settings will appear in the two windows below the screen, so you don't have to remove your eye from the viewfinder to determine what has been set. An LED will light next to the shutter speed scale on the right side to indicate the shutter speed suggested for correct exposure. If this agrees with the speed you have manually set, the exposure will be correct according to the light meter's recommendation.

In Manual mode, you must make changes to the shutter speed and aperture yourself. The LED is just a visible reminder of what the exposure should be, but again, the camera's meter is not foolproof; you may intentionally want to overexpose a snowy scene by two stops to get a white, rather than gray, rendition.

Exposure Compensation

The camera's meter averages the light reflected in the viewfinder and sets the exposure presuming that the subject is of average light reflectance, 18 percent gray. For scenes that have an average range of highlights, midtones, and shadows, this calculation creates a well-balanced photograph, and it is unnecessary for you to compensate for the meter's suggested exposure setting. However, if you are photographing scenes containing an overabundance of highlight or shadow tone (bright or dark areas), you will probably want to use the exposure compensa-

tion feature. In such situations, you can use it to correct the exposure to create highlights or shadow tones that more accurately render the actual color values. Without compensation, your photos are likely to be gray and flat.

The exposure compensation control is a notched lever located at the front of the dial surrounding the back cover release knob. The amount of adjustment in full f/stops is indicated by the numbers on the exposure compensation index. In other words, "+1" denotes one f/stop more exposure than set by the meter, while "+2" denotes two f/stops more. Conversely, "-1" is one f/stop less exposure, and so on. There is a lock at the neutral "0" position and click-stops at each of the numbered positions. The index can also be set at intermediate positions for half-stop exposure adjustments.

To increase exposure (or overexpose) from the metered value, first depress, then move the index to the plus (+) numbers. To decrease exposure (or underexpose) from the metered value, depress and move the index to the minus (-) numbers. For instance, you might use a setting of +1 or +1.5 to more accurately record a snowy landscape and -2 to photograph a black cat on a black velvet cushion.

Caution: *Always return the exposure compensation control to the zero ("0") position after use. Otherwise, the remaining exposures will all be biased to whatever exposure compensation was set.*

Metering

The XD-11's center-weighted metering system is driven by a silicon photo cell mounted within the pentaprism. Although light from all parts of the image area is measured, the primary emphasis is placed on the brightness level recorded in the broad central area of the picture. Satisfactory exposures should be obtained without needing any exposure compensation as long as the primary subject area is of average reflectance and located in the central portion of the viewfinder field.

If the subject is relatively small, or is far off-center, move closer until it fills most of the frame. You now have two options. In auto-exposure modes (Aperture or Shutter Priority), mentally note the recommended exposure (i.e., the f/stop and shutter speed). Then move back to the desired position and use the exposure compensation function until the correct exposure is set. It should be identical to that found before you recomposed. Frankly this exercise is tedious, so you may prefer to switch to the Manual mode. Simply make the settings necessary, then move back to the shooting position and take the picture, ignoring warnings of incorrect exposure.

Other Camera Controls

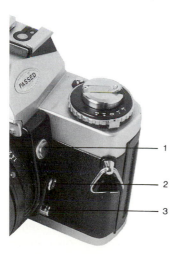

On the front of the camera body to the left of the lens are three controls. The uppermost control is the button for releasing the bayonet-mount MD or MC lens. In the center is a PC terminal for connecting a flash unit with a standard PC cord. Near the base is the stop-down (or depth-of-field) preview button. When it is

1 Lens release button
2 PC terminal
3 Stop-down button

41

depressed, this button allows you to preview the depth of field at the aperture set on the lens ring. To the right of the lens on the front of the camera is the lever that winds the self-timer.

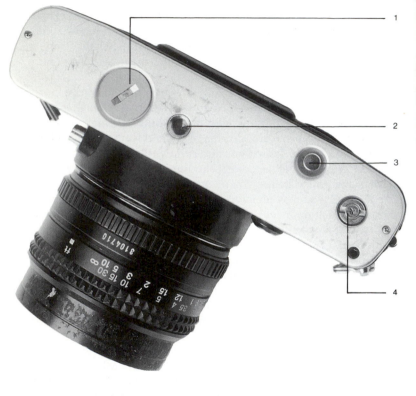

1	Battery chamber	3	Film advance release
2	Tripod socket	4	Auto winder coupler

On the base of the camera is a small button, the film advance release, that must be pressed in before the film can be rewound manually. A slotted cap covers the battery compartment. A standard 1/4"-20 tripod socket is found in the center of the camera's bottom plate.

The camera back has a handy rectangular slot that holds the end flap from a film box as a reminder of the type of film in use. To the left of the eyepiece is a lever that activates a shutter that covers the rear of the eyepiece. This eyepiece shutter prevents light from entering the viewfinder and adversely biasing the meter reading when your eye is not at the viewfinder. Working with the camera attached to a microscope or making exposures with a remote cable release are typical situations in which you would use the eyepiece shutter.

Flash Controls
The flash shoe on the top of the pentaprism is a conventional hot shoe. Note the large round central X-sync contact and a smaller contact that transmits additional data to the camera from flash units dedicated specifically to work with the XD-11.

Multiple Exposures
Multiple exposures can be made easily with the XD-11. After making your first exposure, press the film advance release button on the base of the camera body directly below the shutter release button. This lets you cock the shutter without moving the film forward to the next frame. Since the film remains stationary, any number of exposures can be made on the same frame. To make your next single exposure, advance the film without pressing the film advance release button.

Minolta XD-5

The Minolta XD-5 camera is practically identical to the XD-11. The only difference is that it lacks the direct aperture and shutter speed readout windows at the bottom of the viewfinder (used on the XD-11 to show the shutter speed and the actual aperture set on the lens).

XD Accessories and Rokkor Lenses

Accessories for the XD series cameras include the Auto Winder D and the winder-synchronized Auto Electroflash 200X. When the latter is mounted and turned on, it electronically sets the camera's shutter speed for flash synchronization.

Over the years, Minolta has manufactured many different bayonet-mount Rokkor-X lenses: 32 Minolta MD Rokkor-X bayonet-mount prime (single focal length) lenses (from 7.5mm fish-eye to 400mm f/5.6 Apo telephoto), 14 zoom lenses, 5 mirror lenses (250mm f/5.6 to 1600mm f/11), and 4 specialized bellows lenses.

Virtually all of the earlier MC Rokkor-X lenses and all applicable Minolta SLR system accessories also fit the XD-11 camera, but will not function in all exposure modes.

Using Rokkor-X Lenses

MD Rokkor-X lenses couple fully with all of the automatic features found on the XD-11 and XD-5. MD Rokkor-X lenses couple with the camera for AE operation when the lens is set to its smallest aperture. The last of this series, designated Minolta MD, has a switch that locks the aperture ring on the smallest aperture.

The earlier MC Rokkor lenses will fit the XD cameras and are usable in all modes except Shutter Priority. Older versions of Auto Rokkor bayonet-mount lenses have no meter coupling lug, so metering is achieved by stop-down method only.

To mount a lens to an XD camera, match the red dot on the lens with the red dot just below the pentaprism on the camera body and insert the lens. Next, twist the barrel clockwise 54° in a single, smooth motion until a click is heard. The lens is removed by depressing the top button on the left side of the lens to unlock it, then twisting the lens counterclockwise.

Auto Winder D

The Minolta Auto Winder D was designed specifically for use with the Minolta XD-11 camera, however it also fits the XD-5. This accessory makes it easy to capture action sequences without having to advance the film manually between frames. The electronic and mechanical couplings are meshed automatically when the Auto Winder D is attached to the camera's base. It is powered by four AA-size alkaline batteries.

You can expose approximately two pictures per second for as long as the shutter release button is held down. If you press down on the shutter release only momentarily, it will allow you to make a single exposure. But because the film has advanced, you will be ready instantly for the next shot at an opportune moment. (A switch on the Auto Winder D also allows you make as many multiple exposures as desired on one frame of film.) Since it is small and lightweight, the Auto Winder D is convenient to hold and to store in your bag.

The exposure will be automatically set in AE mode, even when the winder is operating at its highest speed of 2 frames per second (fps). The winder automatically slows its operation if the selected shutter speed will not allow for the full 2 fps advance rate. At the end of a roll of film, the Auto Winder D automatically shuts off. This prevents overwinding, which could tear the film.

Data Back D
The Data Back D replaces the camera's regular back and is used to imprint the date or other useful information on the film as the exposure is being made. Letters and blank spaces can be imprinted for scientific or informational purposes. Power is supplied by two 1.5v silver-oxide S-76 cells or the equivalent.

The imprinting function synchronizes with the camera's shutter by means of a cord that is inserted into the camera's PC sync terminal. Three large dials are used to set the day, month, and year on the bottom right-hand corner of each picture. A red LED on the back serves as a battery check and also lights to signal that data is being imprinted. The data exposure intensity can be adjusted for normal or high-speed films.

Flash Photography with the XD-11

Any Minolta flash unit with an "X" in its model number can be used with the XD-11 and XD-5 cameras' dedicated system. These flash units automatically set the camera to the X-sync shutter speed when they are attached to the camera and the capacitor is charged. First set the camera to "A" mode, and the lens to the desired aperture. With Minolta Direct Autoflash units, the exposure is controlled by internal metering as the picture is made. The

metering engages when you press the shutter release button. A silicon photocell adjacent to the mirror box measures the light from the flash that is reflected off the film plane. This measurement is relayed to the camera's computer, which adjusts the duration of the flash for accurate exposure with any film and lens combination.

Direct Autoflash metering has a definite advantage. Any desired aperture can be set on the camera's lens. This gives the photographer more creative control over the situation.

Minolta XD Auto Electroflash 200X
Minolta manufactured several flash units for use with the XD-11 camera: the Minolta XD Auto Electroflash 280PX, 220X, 200X, 118X, and the Macro 80PX. The most popular was the Auto Electroflash 200X. It offers two features that were very innovative at the time it was introduced: the flash automatically sets the camera to the proper sync speed (1/100 second), plus a red triangular LED in the viewfinder blinks when the flash is ready to fire.

The 200X is powered by four AA-size batteries. It is advisable to clean the battery contacts with an ordinary pencil eraser or clean, dry cloth before installing new batteries. When inserting the batteries into the flash unit, be certain that the plus (+) and minus (-) ends of the batteries are positioned as indicated inside the battery chamber.

To activate the unit and charge the capacitor, move the power switch to "ON." In three to five seconds, the ready light on the flash and in the camera's viewfinder will illuminate, indicating that the flash is fully charged and ready for use. If the flash ready monitor does not light within 30 seconds (when the power switch is on), the batteries should be replaced. When you are done taking flash pictures, be sure to turn the unit to "OFF" so that the flash will not fire.

On the back of the 200X, just below the dial, is a sliding switch to set one of two modes, "AUTO" and "M" (Manual). The yellow "AUTO" setting is the more powerful. When used for close-ups, a smaller lens aperture can be used to achieve greater depth of field. The red "AUTO" setting offers faster recycling at close distances. In either "AUTO" setting, the closer the subject, the shorter the recycle time will be—less of the stored flash power is used for nearby subjects.

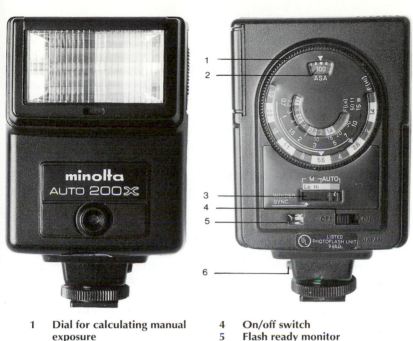

1 **Dial for calculating manual exposure**
2 **ASA (ISO) window**
3 **Sliding switch for setting "AUTO" and "M" modes**
4 **On/off switch**
5 **Flash ready monitor**
6 **Test flash button**

In "M" mode, the "HI" setting provides more light for greater flash-to-subject distances or smaller apertures for greater depth of field with nearby subjects. The "LO" setting is intended primarily for use with the Auto Winder D or when faster recycling is desired for nearby subjects.

Minolta XD-11 Specifications

Type: Compact 35mm SLR with Shutter and Aperture Priority automatic or Metered Manual exposure control.

Standard Lens: 50mm f/1.4 or f/1.7 MD Rokkor-X.

Lens Mount: Minolta SLR bayonet mount; coupling for full aperture metering and finder display input.

Metering: TTL averaging type with more influence from central zone of screen. Silicon photocell mounted at rear of pentaprism.

Autoexposure Range: EV 1 to EV 18 with ISO 100 film, 50mm f/1.4 lens.

Exposure Modes: Automatic diaphragm control providing Aperture and Shutter Priority operation with MD Rokkor-X lenses.

Exposure Controls: Continuous adjustment can be set to +/- 2 EV in Automatic or Manual modes, with locks at "0" and each EV setting. Depth-of-field preview and stop-down meter readings.

Flash Sync: PC terminal and hot shoe for X sync. Electronic flash synchronizes at 1/100 second and slower or stepless speeds; class MF, M, and FP flashbulbs sync at 1/15 second or slower. Additional contact on hot shoe receives signal from camera control contact of Auto Electroflash 200X when capacitor is charged causing upper LED triangle to blink and set shutter at fixed 1/100 second.

Shutter: Vertical-traverse, metal-blade, focal-plane type with electromagnetic release. Electronically controlled, stepless speeds of 1 to 1/1000 second on Automatic modes or in steps on Manual mode or X sync (1/100 second). Mechanically controlled settings (requiring no battery) at "0" and "B."

Film Speed Range: ISO 12 to 3200.

Film Transport: Lever-type manual film advance; release button for rewinding and multiple exposures. Safe Load Signal indicates

loading and advancing status. Motorized film advance possible with Auto Winder D accessory.

Viewfinder: Eye-level fixed pentaprism showing 94 percent of image area; viewing area 24 x 36 mm; magnification 0.87x with 50mm lens at infinity.

Viewfinder Display: Shutter speed and f/number; LED over- and underrange indicators; flash ready signal with Auto Electroflash 200X; LED lights for "X," "0," and "B" settings. Built-in eyepiece mask.

Power: Two 1.5v silver-oxide batteries, type S-76 or equivalent, power camera's autoexposure control and shutter's electronically governed operation. Check batteries by depressing shutter release slightly—LEDs will be dim or unlit as batteries approach exhaustion. Shutter will not release if batteries are too low to operate camera sufficiently.

Dimensions: 2 x 3-3/8 x 5-3/8 in. (51 x 86 x 136 mm) without lens.

Weight: 19-11/16 oz. (560 g) without lens or batteries.

Minolta Maxxum (Dynax) Series

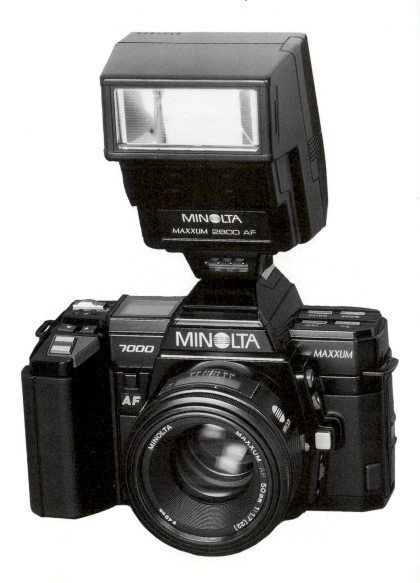

Maxxum Series Compatibility

In 1985 when the original Minolta Maxxum 3000, 5000, and 7000 were introduced, they were the first AF (Autofocus) SLR cameras available from a major camera manufacturer. The professional Maxxum 9000 was introduced later the same year. At first there was little if any competition for these Maxxum AF cameras. However, after about three years most of the other major camera manufacturers had several autofocus models in their product line. So, in 1988 a second generation of Maxxum cameras with improved features and capabilities was introduced. These cameras were designated the 3000i, 5000i, 7000i, and 8000i. In 1991 Minolta unveiled its third-generation Maxxum system, designated "xi" (short for "expert intelligence"). This more refined series started

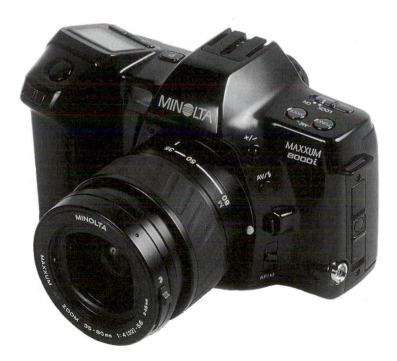

with the 7xi, which was soon followed by the 3xi, 5xi, and 9xi. The 700si was introduced in 1993 and was soon accompanied by the 400si (known as the Dynax 500si in other markets), and in 1995, the 300si and the 600si. Each Maxxum generation incorporated significant improvements in the camera, lens, flash functions, and features. Despite the number and variety of Maxxum products Minolta has introduced through the years, there is considerable compatibility between the many accessories offered for the various models.

However, one source of incompatibility is found in the difference in the flash hot shoe of the original Maxxum cameras (models 3000, 5000, 7000, and 9000) and the later "i," "xi," and "si" models. The original series had a conventional hot shoe with electrical contacts. The three later generations feature a dual-rail hot shoe unique to Minolta that includes a locking mechanism to keep the flash firmly seated in the camera's flash shoe. Fortunately, there are special adapters available that permit you to use any flash unit with a standard foot on newer dual-rail shoes or vice versa. So even this minor incompatibly problem can be easily solved.

Of course, you will not be able to fully utilize all the features found on early Minolta AF lenses with more recent camera bodies. And, although the original Maxxum camera models will accept newer Minolta AF lenses, they cannot take advantage of some of the newer features offered by the recent lenses intended for Maxxum bodies of higher sophistication. This book will further address the compatibility of various generations of products to enable readers to take full advantage of all of their Minolta Maxxum equipment no matter what vintage.

The Autofocus System

Early in 1985, Minolta introduced the first autofocus interchangeable lens SLR camera, the Maxxum 7000, and photography has not been the same since. Most professional photographers with a considerable amount of practical experience predicted that autofocusing would find acceptance with the masses of people who desired a quick, easy method of obtaining consistently sharp pictures. But they also tended to believe that autofocus was just not

accurate or fast enough for a working professional. Shooting just a few rolls of film on a variety of subjects have convinced these photographers that autofocus is a truly revolutionary technological step forward that makes earning a living with a camera a bit simpler and easier.

Advances in technology have allowed autofocus systems to be continually improved and updated with features like wider focus detection areas, faster motors, and predictive tracking capabilities for moving subjects. This "predictive" AF, available in Maxxum "i" series and later cameras, sets focus for the position a subject will reach at the instant of exposure after all camera settings have been made automatically.

Using Autofocus

Although the autofocus system in Maxxum cameras does an excellent job of finding proper focus on most subjects, it can be fooled or misled, and may not be able to cope with a few unusual subjects. The cameras' autofocus mechanisms respond to the contrast of the subject. Hence, if your subject has minimal or no detail or texture (like a plain white wall, glass window, or flat side of a building), the autofocus mechanism cannot achieve focus. The AF system will then drive the lens between infinity and its closest focus point seeking some contrast or detail, but usually it will fail. In that case, the viewfinder focus signals will blink indicating an out-of-focus condition.

Note: The Maxxum 7000, 7000i, and 8000i have a "focus priority" feature that locks the shutter when focus cannot be achieved. The Maxxum 9000, however, does not have this feature and photos can be made whether the subject is in focus or not.

In situations of this type, try aiming the focus area in the viewfinder toward another subject that has some contrast or texture and is a similar distance from the camera. Use the camera's focus hold feature to lock focus while you recompose the photo.

Another solution is to shift to manual focus. Set the focus mode switch to the "M" (Manual) position. Then, critically focus the subject by turning the focusing ring. A plain, non-textured subject may also frustrate the eye, so take care to achieve adequate focus.

If shooting at a mid-range lens aperture (f/8, f/11, or smaller),

there will be adequate depth of field to mask a slight focusing error. If you are shooting a close-up subject, or with a telephoto lens at a wide aperture (such as f/4), depth of field will be shallow. Critical focus is essential if you expect to obtain acceptable results.

Another situation that will present a problem to any make of autofocus system is when you are photographing something through a busy foreground: an animal behind bars at a zoo or bare tree branches, for example. Unless the bars or branches are quite wide (or close to the camera so the autofocus detection area can be placed between them), focus will be set for the foreground instead of the intended subject. It is advisable in this situation to switch over to manual focus.

One problem that is common to some AF systems but will not stop the Maxxum autofocus system is photographing in low-level lighting or complete darkness. The camera will sense the light level, and if it is too dark to focus adequately, an AF illuminator built into the camera or flash will automatically project a pattern of red light to assist the AF sensors. There are, however, a few situations in which the AF illuminator may not operate, such as when part of the lens blocks the optical path of the AF illuminator (as with the Apo Telephoto 200mm and 300mm lenses) or in macro photography when the subject is closer than three feet (.9 m).

Auto Film Speed Setting

For a number of years, all 35mm films have used DX coding (a checkerboard pattern of silver and black boxes on film cassettes) to convey information to the camera, such as film speed and the number of exposures on the roll. This data is read by sensors inside the body of all Maxxum cameras, allowing film speed to be set automatically.

Virtually every brand of film purchased today comes in a DX-coded cassette, but, if you shoot a lot of film, you may decide to buy long, bulk film rolls to keep costs down. In that case, you'll probably use blank film cassettes without DX coding, so you will have to set the ISO manually for each roll loaded. For more information, see *Setting the Film Speed* in the Maxxum 7000, 9000, and 7000i chapters, and *Auto DX Memory* in the 8000i chapter.

Minolta Maxxum (Dynax) 7000

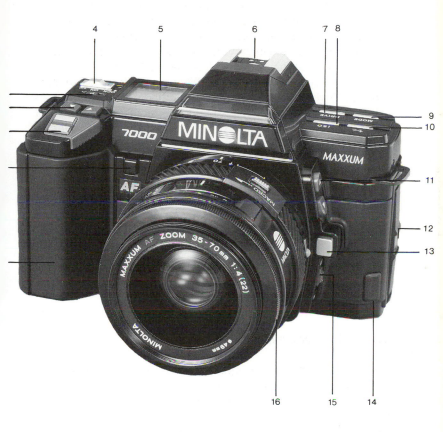

1	Operating button/shutter release	10	Exposure compensation key
2	Shutter speed keys	11	Aperture keys
3	Program reset button	12	Back cover release
4	Main power switch	13	Lens release button
5	LCD data panel	14	Remote control terminal
6	Accessory shoe	15	Focus mode switch
7	Drive mode key	16	Focusing ring
8	Film speed key	17	Battery holder
9	Exposure mode key	18	Self-timer LED

When the Maxxum 7000 was introduced in 1985, the entire photo industry took immediate notice. (This camera is called the Dynax 7000 in markets outside North America.) It was the the world's first 35mm SLR with body-integral autofocusing. Other major camera manufacturers quickly began playing catch-up.

This camera was totally new in every way. It featured automatic multi-program autoexposure. The latest in computer technology, this camera incorporated two 8-bit CPUs (Central Processing Units) and six ICs (Integrated Circuits), the equivalent of more than 150,000 transistors. A ROM (Read Only Memory) IC was integrated into each of the Maxxum AF bayonet-mount lenses to deliver pertinent information to the exposure and autofocus systems in the camera body. This eliminated the need for mechanical input lugs or a lens aperture ring, necessary with earlier SLRs, to relay information from the lens to the camera body. Time-consuming decisions and camera adjustments were no longer necessary thanks to the Maxxum's speedy micro-computer system, which updates itself more than 33 times each second. The Maxxum 7000 earned the European Camera of the Year '85 and Japan Camera Grand Prix '85.

The original list price of a Maxxum 7000 camera with AF 50mm f/1.7 lens was $508.00 in the USA.

Important Features

The ergonomic design of the Maxxum 7000 SLR is solid and comfortable, if somewhat chunky. The protruding grip on the right side of the body includes a raised area on the back for the right thumb, allowing for a comfortable, secure grasp of the camera. It also houses the batteries. The 7000's operation is simplified by its easy-to-use touch keys, which replaced the more traditional dials and levers found on earlier SLR cameras. The viewfinder is illuminated for better visibility in low-light situations and film handling is totally automatic from loading to rewinding.

A fixed eye-level pentaprism shows 94 percent of the film frame. The focusing screen can be changed, and dioptric correction lenses are available. Audible warning signals are available if desired.

The Maxxum 7000 displays all pertinent information legibly across the bottom of the viewfinder screen, outside the image area.

Viewfinder data include: focus signals, flash ready and flash confirmation signals, exposure mode ("P," "A," "M," or "S"), shutter speed, metering (up or down arrows), aperture, and exposure compensation (+ or -). The viewfinder also illuminates in dimly lit situations.

The viewfinder of the Maxxum 7000 gives you a great deal of valuable information: focus signals, flash signal, exposure mode, shutter speed, film speed, metering indicators, aperture setting, and exposure compensation reminder.

An LCD panel on the camera's right shoulder includes all necessary operating information, duplicating most of the information displayed in the viewfinder. The LCD also displays information not shown in the viewfinder: single-frame or continuous advance drive mode, self-timer mode and countdown, and frame counter. Focus information, however, is visible only in the viewfinder.

If the LCD panel or viewfinder display flashes, either there is an erroneous setting or the selection is beyond the range of exposure. If all displays blink, this indicates that the batteries are weak and should be replaced.

The Maxxum 7000 is powered by four AAA-size 1.5v alkaline-manganese batteries. Minolta specifies that under normal operating conditions, one set of batteries will expose approximately 25 rolls of 24-exposure film. Two optional AA-size battery packs are available. One replaces the smaller standard grip, and the other is designed to be carried in the photographer's pocket, where it will stay warm when the camera is used under extremely cold weather conditions. Both battery packs power approximately 65 rolls of 24-exposure film. A built-in lithium battery (which Minolta rates for 10 years) maintains the camera's memory if the standard

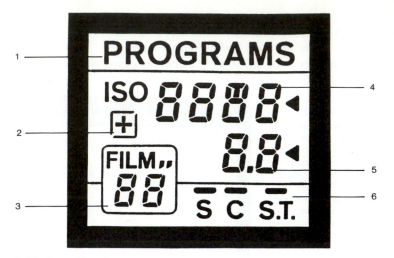

LCD Data Panel

1	Exposure modes	4	Shutter speed/film speed
2	Exposure compensation reminder	5	Aperture adjustment/exposure compensation
3	Frame counter/self-timer countdown/bulb elapsed time	6	Drive modes/self-timer

batteries are depleted or removed. This lithium battery must be replaced by an authorized Minolta service center.

There is no conventional aperture ring or traditional shutter speed dial. Exposure adjustments are made automatically by the camera or manually by the photographer using the camera's up or down push-button switches. This information is displayed in the viewfinder and on the LCD panel.

Metering is accomplished by silicon photo cells in a center-weighted pattern. Shutter speeds range from 30 seconds to 1/2000 second and also include "B" (Bulb) and X sync at 1/100 second. Other features include interchangeable focusing screens, a built-in film winder with continuous speeds of up to 2 fps (frames per second); self-timer; automatic film speed setting for DX-coded films (with override); and automatic, motorized film loading and rewind. Optional accessories at the time of the camera's introduction included: 12 Minolta A-mount lenses, three dedicated flash units, and two program backs.

Exposure modes include Aperture Priority ("A"), Shutter Priority ("S"), Metered Manual ("M"), and Program ("P") with three AE settings: Wide (for focal lengths shorter than 35mm), Standard (35 to 105mm), or Tele (105mm or longer). Exposure adjustment is from EV +4 to -4 in half-stops. Buttons are used to control all operating functions. Lightly touching the operating button activates the metering and LCD displays; pressing halfway down activates autofocus and focus hold. Fully depressing the button trips the shutter. The built-in motor drive has single-frame or continuous advance up to 2 fps.

Using the Maxxum 7000

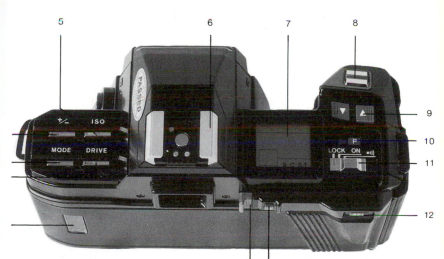

1	Film window	9	Shutter speed keys
2	Drive mode key	10	Program reset button
3	Exposure mode key	11	Main power switch
4	Exposure compensation key	12	Autoexposure lock button
5	Film speed (ISO) key	13	Rewind release
6	Accessory hot shoe	14	Rewind switch
7	LCD panel		
8	Operating button/shutter release		

Control Locations

Sure, it takes some time to become accustomed to the location of all the operating controls, but once you are familiar with them, they are quite simple to use. They are conveniently located, easy to see and to operate.

The Maxxum 7000 has a main power switch. This switch should be set to "LOCK" whenever the camera is not in use to prevent battery drain or unintended exposures. To operate the camera, switch the main power switch to "ON" or the audible signal symbol,))). Both settings activate the camera's shutter release (or operating button, as Minolta calls it.) The operating button/shutter release also serves to activate the meter, autofocus, and focus hold functions. Selecting the audible signal not only turns the camera on, but also activates a beep to indicate when a subject is in focus, the shutter speed is too slow for handheld exposure, the self-timer is activated, or your film has run out.

1	Shutter release	4	Lens release button
2	Self-timer LED	5	Back cover release
3	Aperture setting keys	6	Focus mode switch

Setting the lens opening or shutter speed (when not in Program ["P"] mode) is quickly done by touching one of two up or down buttons for the aperture or shutter speed adjustment. Returning to Program mode is as easy as touching the program reset button, no matter what mode the camera is in.

Loading and Unloading the Film

Before opening the camera back, always check the film window to see if film is loaded, and check the film counter to be certain that the film is completely rewound and "0" is displayed.

When loading your film, be sure to extend the film leader slightly past the red leader index (1) below the take-up chamber, and make sure the film is flat. It is important that the perforations in the lower edge of the film leader engage the teeth on the sprocket (2).

Now switch the camera's main power switch to "ON." Open the back by sliding the back cover release button downward. Do not touch the black shutter curtain in the middle of the film path or the pressure plate on the camera back.

Next, drop the film cassette into the left compartment, and extend the tip of the film leader slightly past the red index mark on the right below the take-up chamber. Make sure that perforations in the lower edge of the film leader engage the teeth on the sprocket. If the film extends too far or does not lie flat, gently push the excess film back into the cassette. There are no film slots or take-up spool to contend with.

Close the back cover by pressing it until it snaps shut. The camera will automatically advance the film to the first frame. The frame counter on the LCD panel will show "1" indicating the film is properly loaded and engaged. If the frame counter still shows "0" (indicating the film is not loaded properly), open the back and repeat the above steps.

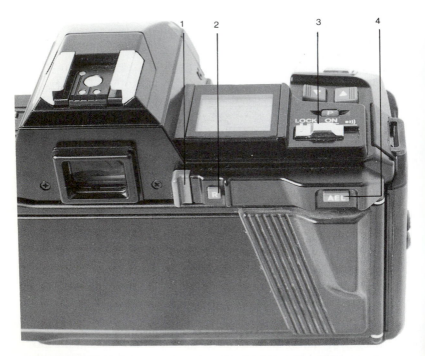

| 1 | Rewind switch | 3 | Main power switch |
| 2 | Rewind release | 4 | Autoexposure lock button |

Note: Film should always be loaded in subdued light or the shade of your body. Never load any 35mm camera in bright sunlight as doing so could fog your film.

If the film cartridge has DX-coding, sensors will read the ISO speed and set the camera automatically. The set film speed is displayed briefly in the viewfinder and on the LCD panel for confirmation. The ISO may be set manually if desired (see below).

After the last frame of film has been exposed, both "FILM" and the frame number on the film counter will blink, and the camera will beep if the power switch is set on audible mode,))). The shutter will lock and exposure settings on the LCD panel will disappear until the film has been fully rewound.

To rewind, press the rewind release button ("R") on the camera's back just below the LCD panel, and slide the rewind switch next to it to the left. (The rewind switch will stay in this position; you do not have to keep holding it.) While the camera rewinds, the word "FILM" will continue to blink on the LCD panel. After the film is completely rewound, "FILM" will remain blinking, "0" will appear in the frame counter, and you can remove the cassette.

Note: If the camera stops rewinding before "0" appears, *do not open the back.* Slide the main power switch to "LOCK," insert fresh batteries, and then slide the switch to "ON" to finish the rewinding cycle.

Setting the Film Speed
With any DX-coded film, the ISO film speed is automatically set and displayed for ten seconds on the LCD panel when the camera back is closed. You can check the speed of the film at any time by pressing the film speed key (marked "ISO") on the top left of the camera. If desired, the film speed can be set manually to a higher or lower value after the film has been loaded.

To do so, press and hold down the film speed key. Then, press either the up or down shutter speed keys to increase or decrease the ISO speed value. Each time the key is pressed, the setting will change by one-third. This value will be displayed on the LCD panel. These settings will change rapidly if the shutter speed key is held down.

Exposure Modes

The Maxxum 7000 offers four exposure control modes: "P" (Program), "A" (Aperture Priority), "S" (Shutter Priority), and "M" (Metered Manual). You must select the one appropriate for the type of situation you are photographing.

Selecting the Exposure Mode
Setting exposure modes is accomplished by a simple two-step operation. While pressing and holding down the exposure mode key on the top left (labeled "MODE"), press either of the shutter speed up and down keys until the desired mode is displayed on the LCD panel. "PROGRAM," "A," "S," or "M" will appear at the top of the LCD, displaying the mode selected.

Program Mode
You may sometimes wish to quickly reset the camera to Program mode with single-frame film advance and no exposure compensation. To do so, simply press and release the program reset button, marked "P," above the power switch on the upper right of the

Bubbles are fleeting, so using Program mode is handy for capturing them as they swirl in the air.

camera. This is a quick and simple method of returning to totally automatic program operation from any other mode.

In "P" mode, AMPS (Automatic Multi-Program Selection) automatically selects one of three programs to match the focal length of the lens in use. All you have to do is compose the image in the viewfinder and make the exposure. The lens aperture and shutter speed are set automatically and displayed both in the viewfinder and on the LCD panel. With lenses shorter than 35mm, the "wide" program sets smaller apertures for greater depth of field. With 35mm to 105mm lenses, the "standard" program chooses the optimum shutter speed and aperture. (As usual, this combination depends on the scene's brightness). With lenses longer than 105mm, the "tele" program selects faster shutter speeds to minimize possible blur caused by camera shake or movement. If you are using a zoom lens, the program shifts automatically as the lens is zoomed in or out. The system reads the current focal length and automatically makes any necessary changes in the program.

Note: If the shutter speed is too slow for good hand-held pictures, the Maxxum 7000 will beep to warn you that a sharp picture is unlikely. Mount the camera on a firm support such as a tripod, or use flash.

Program Shift: The Program Shift capability allows the photographer to adjust the combination of aperture (f/stop) and shutter speed in the fully automatic Program mode. By touching either the up or down shutter speed keys or aperture keys, the photographer can select other shutter speed or aperture combinations that give the same exposure value. The settings will appear in the viewfinder and on the LCD panel. In action photography, you may want to select a combination with a higher shutter speed to freeze motion. With landscapes, you may decide to shift to a combination with a smaller aperture (large f/number, such as f/16). This will provide a deeper depth of field for a greater range of sharpness.

Note: All of the available combinations produce equivalent exposure. The camera selects combinations of apertures and shutter speeds that allow exactly the same amount of light to expose the film. In other words, the overall brightness of the photo will not be affected.

Program Shift may eliminate the need to change over to Aperture or Shutter Priority mode. It maintains the selected combination as long as you have contact with the shutter release button. To make several exposures with the same settings, keep your finger on the button between exposures. Program Shift will cancel ten seconds after removing your finger from the shutter release. Also, the program combination will revert back to that selected by the system after you take the picture. If you want to shoot a series of photos at a specific aperture or shutter speed setting, the semi-automatic ("A" or "S") modes are a better choice.

Aperture Priority Mode

Aperture Priority ("A") mode allows the photographer to control the image's depth of field. By setting a wider aperture (e.g., f/2.8), a narrow range of sharpness will be achieved, placing emphasis on the subject by blurring the background. In scenic photography, we often want the entire vista to be reproduced sharply, from foreground to background. This effect is achieved by setting a smaller aperture (e.g., f/16).

With the camera in "A" mode, select the lens aperture in half-stop increments with the up and down buttons. The camera's metering system will automatically select a corresponding shutter speed for accurate exposure. The shutter speed settings are stepless. For example, the system can select 1/329 second, 1/68 second, 1/542 second, or whatever is necessary to produce the best exposure. The nearest half-step is displayed on both the viewfinder and the LCD panel.

If the shutter speed required is too slow for handheld exposure and the main power switch is set to))), the camera will warn you with a beep. It is then advisable to mount the camera on a tripod or switch to a faster film.

Shutter Priority Mode

Shutter Priority ("S") mode allows the photographer to select the shutter speed. The system responds by setting the corresponding f/stop. This is ideal for photographing moving subjects because the photographer can select the appropriate shutter speed to portray the action. For instance, faster shutter speeds up to 1/2000 second will freeze almost any fast action. Or you might prefer to choose a slower shutter speed to intentionally blur the fluid

movement of an athlete or a waterfall. The camera will not override your selection. In the "S" mode, the automatic system will steplessly set the appropriate lens aperture and display it to the nearest half-stop.

Metered Manual Mode
The final mode choice is "M," or Metered Manual. In this mode you have full manual control of both components of the exposure. You select both the shutter speed and lens aperture. However, if you have set the main power switch to))) and have selected a shutter speed that is too slow for handheld exposure, the camera will beep. The metering indicators in the viewfinder can be followed or ignored. You may decide to base the exposure on readings made by a handheld meter or by personal experience. (You can also refer to the exposure recommendations included with most rolls of film.)

Focusing

Autofocus
By today's standards (with three more generations of Maxxum autofocus technology in the "i," "xi," and current "si" systems), the autofocus (AF) system of the Maxxum 7000 adjusts focus in a somewhat relaxed, leisurely fashion. Not to say that the 7000's autofocus is slow, but the current technology is dramatically faster. Minolta's initial approach to autofocus with the 7000 integrated all AF functions into the Maxxum body. It was said that even the most proficient photographer could not match the accuracy and repeatability found in the first Maxxum autofocusing system. Minolta designed an additional advantage in the 7000. Unless the focus is correct, the camera will not allow a picture to be made. In addition, when the main power switch is set to))), the camera will beep when the subject is in focus.These are beneficial features for beginning photographers who tend to be "trigger-happy," trying to snap the picture before the subject is in focus. When the camera is set for autofocus, the lens' focusing ring cannot be turned; hence, focus cannot be inadvertently changed.

The Maxxum 7000 has two autofocus modes: Single-Frame Advance ("S") with an AF lock feature and Continuous Advance ("C"). The autofocus action of this original AF SLR is rapid and

accurate. Autofocus works in all four exposure modes, including Manual.

To activate single-frame advance AF, set the focus mode switch (on the left of the camera near the lens mount) to "AF" and the drive mode key (on the top left of the camera) to "S" (Single-Frame). Aim the camera, placing the primary subject inside a small horizontal rectangle in the center of the screen. Press the shutter release down slightly. This will activate the focusing mechanism. When the subject within the rectangle is in critical focus, a green LED will light in the viewfinder. The focus will lock on the central subject until the shutter is tripped or the shutter release is pushed down all the way.

For continuous autofocus, set the focus mode switch to "AF" and the drive mode key to "C" (Continuous). Again, a light touch on the shutter release will activate this feature. Instantly (in 0.55 seconds or less with any AF lens) the camera focuses, and the green LED confirms that the subject is in focus by lighting in the view-finder. This early form of continuous AF is useful for photos of subjects that are not moving very quickly, such as children at the park. The motion can be followed with continuous autofocus as long as the primary subject is within the rectangular area and the shutter release is lightly depressed.

For both AF modes, if the subject area is not in focus, a red tri-angular LED will point in the direction that the focus will be shifted. If two red triangular LEDs light and flash, this is a warning that the AF mechanism cannot find proper focus. Even if the shutter release is depressed all the way, the exposure will not be made until the subject is in focus. The type of subjects that might per-plex the autofocus are extremely even-toned, flat subjects, overly busy subjects (a group of bare tree branches), extremely bright subjects (reflections), and very dimly illuminated subjects.

The "passive" autofocusing system of the 7000 does have some other limitations. The primary factor is the amount of light required. The autofocus system will operate in light levels as low as EV 3 with apertures as small as f/5.6. Below this threshold, it is probably best to switch over to manual focus. But with a Maxxum dedicated flash attached to the camera's hot shoe, it is possible to photograph successfully in near darkness because the flash unit incorporates an autofocus assist feature. This is automatically activated when conditions and subjects are not ideal for autofocusing.

Manual Focus with Focus Assist

To focus manually, slide the focus mode switch to "M" (Manual), and turn the narrow, 5/32" knurled ring at the front edge of most Minolta AF lenses. (Do not attempt to focus with the wide, diagonally knurled, half-ring on the bottom of the lens.) When switched to manual focus, the AF system remains active for "focus assist." One of the red arrows will light on the base of the viewfinder, indicating which direction to turn the ring for correct focus. When focus is achieved, the green dot will light below the viewfinder, and the subject will appear sharp on the viewing screen. At this point, if the main power switch is set to))), the camera will also beep indicating that the subject is in focus. You can now take your picture, fully depressing the shutter release. Of course, you do not have to heed these indicator lights. You can focus manually using the viewfinder screen or the scale settings on the lens barrel. But, this focus assist feature is still handy, especially to confirm focus in low light or with hard-to-focus wide-angle lenses.

If both red arrows light, focus must be achieved visually by turning the focusing ring until the image appears sharp in the viewfinder. The focusing screen is a solid, acute-matte screen without a conventional central microprism circle or split-image spot. To assess focus, you can select any area within the viewing screen that has fine detail.

Manual focus on the 7000 is less convenient than the conventional method of focusing with non-autofocus lenses, and its action is not as smooth. This is tolerable because most people do not often use manual focus with this autofocus camera system. Minolta designed the focusing ring to be small and out of the way so that it isn't accidentally moved.

Other Controls

Autoexposure Lock

A meter reading can be locked (for one exposure only) by depressing the rectangular Autoexposure Lock ("AEL") button conveniently placed on the back of the camera to the right of the rewind release button. The button is recessed so that you can't accidentally press it while gripping the camera. It is useful when the subject is significantly darker or lighter than the area surrounding it.

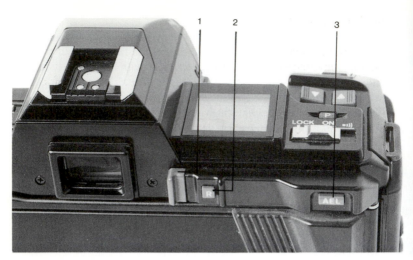

1 Rewind switch
2 Rewind release

3 Autoexposure lock button

Simply fill the camera's viewfinder with the subject you want to expose correctly. Activate the meter by lightly touching the shutter release; then press and hold the AE lock button. While keeping the button pressed, recompose the photo, focus, and release the shutter.

Self-Timer

The 7000 also has an electronic self-timer that delays shutter release for ten seconds. To operate it, press the "DRIVE" key on the top left of the camera and press either of the shutter speed up or down keys until an index appears above "S.T." in the LCD panel. Set your exposures and focus as you normally would and place an eyepiece cap over the eyepiece to avoid stray light from affecting your exposure. When a green LED lights in the viewfinder, press the shutter release down completely. If the main power switch is set to))), the camera will beep to indicate that the self-timer is engaged. The self-timer LED on the front of the camera will blink during the ten-second countdown. To cancel the self-timer before the shutter is released, simply press the "DRIVE" key.

System Accessories

Lens Mount Compatibility

All Maxxum autofocus cameras accept only Maxxum AF bayonet-mount lenses (sometimes referred to as A-mount lenses) or those made for the Minolta AF system by other manufacturers. There is no interchangeability between the Maxxum AF mount and earlier Minolta MC or MD bayonet-mount lenses.

Introduced with the Maxxum 7000 were Maxxum AF lenses ranging from an AF 24mm f/2.8 to a "fast" AF 600mm f/4 apochromatic telephoto. Today there are more than 38 different Maxxum AF lenses that can be used on all Maxxum cameras. However, some of the features incorporated in the newer "xi" and "si" series of lenses cannot be fully utilized with the two earlier camera series. The built-in power zoom feature is the most notable feature that is not functional with earlier Maxxum camera bodies such as the 7000 and 9000.

Early versions of Maxxum AF lenses introduced with the Maxxum 7000 have a narrow focusing ring at the extreme front edge. Designing the focusing ring in this location minimizes the possibility of accidentally moving it during motorized autofocus operation. These lenses also have a focusing distance scale located under a clear plastic window on top of the lens where it is easily visible for reference.

Data and Program Backs

Since the shape of the camera body changed with the later Maxxum cameras, the various data and program backs are not interchangeable between the different series. The backs intended for the early 5000, 7000, and 9000 cameras contain "70" or "90" in their designation. The comparable backs that fit the newer "i" and later Maxxum cameras are designated DB-7 and PB-7 to differentiate between them. More complete data about the various accessories can be found in the chapter *Maxxum Accessories.*

Minolta Maxxum 7000 Specifications

Type: 35mm SLR with microcomputer control of autofocus, auto multi-program, multi-mode, auto film transport, and LCD data panels.

Lens Mount: Minolta A-type, accepts all Minolta AF lenses.

Autofocusing System: TTL phase-detection type with 8-bit micro-computer for direct, digital adjustment.

AF Sensitivity Range: EV 2 to 19 with ISO 100 film in ambient light.

Metering: TTL center-weighted averaging type; silicon photocell on pentaprism for ambient light; spot metering can also be selected; second SPC (silicon photocell) at bottom of mirror box for TTL flash metering with dedicated flash units.

Autoexposure Range: EV -1 to 20 with ISO 100 film, 50mm f/1.4 lens.

Exposure Modes: Program AE, Shutter Priority AE, Aperture Priority AE, Metered Manual.

Exposure Controls: Compensation factor can be set to +/- 4 EV in half-stops.

TTL Flash Metering: Operates in all modes with dedicated flash units; shutter automatically set to X sync of 1/100 second (1/60 second if below EV 12).

Shutter: Electronic vertical focal plane; stepless range of 30 seconds to 1/2000 second.

Controls: Keys set exposure mode, film advance (drive) mode, exposure compensation, film speed, AE lock, and program reset. "Up" and "down" keys select shutter speed or aperture settings and control program shift.

Film Speed Range: ISO 25 to 6400.

Film Transport: Built-in motor drive; single frame or continuous advance at up to 2 fps. Power rewind: manual start and automatic stop.

Viewfinder: Eye-level fixed pentaprism shows 94 percent of frame area; magnification 0.85x with 50mm lens at infinity.

Data Display: Top LCD panel shows exposure mode, program shift, shutter speed, aperture, exposure compensation, film speed, frame number, drive mode, self-timer operation, "bulb" operation, low battery warning.

Viewfinder Display: LCDs show exposure mode, program shift, shutter speed, aperture, exposure compensation, film speed, low battery warning, whether light level is within metering range, over- and underexposure warning. LEDs indicate focus status, if flash is charged, correct flash exposure. Illuminates automatically in low light.

Power: Four AAA-size 1.5v alkaline-manganese batteries power all operations. Built-in lithium cell for memory back-up only.

Dimensions: 2-1/16 x 3-5/8 x 5-7/16 in. (52 x 91.5 x 138 mm).

Weight: 19-9/16 oz. (555 g) without lens and batteries.

Minolta Maxxum (Dynax) 9000

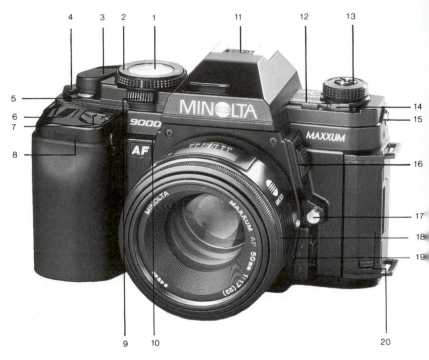

1	LCD data panel	12	Exposure compensation key
2	Exposure mode selector	13	Back cover release/rewind
3	Film advance lever		knob and crank/metering
4	Main power switch		selector
5	Frame counter	14	Lock release
6	Self-timer switch	15	PC terminal
7	Shutter release/operating	16	Aperture up/down control
	button	17	Lens release
8	Self-timer LED	18	Focusing ring
9	Shutter up/down control	19	Focus mode switch
10	Preview switch	20	Remote control terminal
11	Accessory shoe		

When Minolta launched the Maxxum 7000 early in 1985, they hadn't forgotten the needs of the professional photographer. Later

that same year they introduced the advanced Maxxum 9000 (called the Dynax 9000 in markets outside North America). This was the first truly professional AF SLR camera. While the Maxxum 9000 retained the 7000's innovative autofocus features, it also offered many non-automatic functions so the professional photographer could opt for total control when required. It offered built-in capabilities and optional accessories not found in any other Maxxum AF camera, even in the later "i," "xi," and "si" series models. Introducing two innovative SLRs in one year is quite an achievement, even in the rapidly changing world of photography!

The introductory suggested list price of the Minolta Maxxum 9000 with AF 50mm f/1.7 lens was $684 in the USA.

Important Features

The Maxxum 9000 combines the traditional controls and feel of a mechanical 35mm SLR with Maxxum system electronics, including autofocusing. The rugged, alloy, die-cast body is designed for heavy-duty professional use and has a durable, rubberized covering on the right side to provide a secure grip. Three lugs for the neck strap permit the camera to be suspended either horizontally or vertically from the end of its body. Electronic depth-of-field preview, multiple exposure capability, dedicated hot shoe, PC flash terminal, built-in eyepiece shutter, diopter correction, interchangeable focusing screens, an action-stopping top shutter speed of 1/4000 second, and a fast flash sync speed of 1/250 second are just a few of the more desirable professional features.

Although it is fully electronic and highly automated, the Maxxum 9000 does not have the built-in motor drive capability of the 7000. Instead, it features a conventional single- or multi-stroke film advance lever and manual rewind, providing the working pro with quiet film transport. The optional Motor Drive MD-90 can be attached to power both film advance and rewind. Even with the MD-90 attached, the Maxxum 9000 has an uncluttered, sculpted appearance with strategically placed, fully visible operating controls.

The viewfinder's image area is unobstructed for accurate composing. The viewfinder includes 94 percent of the actual image recorded on the film frame. Only the rectangular autofocus area

and the spot metering reference circle are marked. Focus, operating mode, and exposure information are legibly displayed below the image area. In low lighting conditions, the displays illuminate for easier viewing. Minolta offered five user-changeable, accessory focusing screens for the camera. Eyepiece correction diopters from -3 to +1 were also available.

The 9000 introduced a continuous autofocusing system that was more sensitive than that of the 7000, allowing it to operate at lower light levels. Continuous autofocusing mode offers a "release priority" feature, which activates the autofocusing circuitry simply through finger contact with the shutter release button. Once activated, the camera's autofocus establishes correct focus and continues to adjust as needed to maintain correct focus. Pressing down on the shutter release halfway locks the focus to facilitate reframing for optimum composition.

On the Maxxum 9000, tripping the shutter is not dependent upon focus. Hence, when the shutter release is fully depressed, the camera will always fire. This assures that the photographer (not the camera's computer) has complete control in capturing precise action or recording a decisive moment.

Note: To make an exposure, press the shutter release fully with a smooth, steady downward stroke; never jab at the shutter release button.

The metering system is center-weighted, which is adequate for most autoexposure situations. However, since pros tend to be more critical appraisers of any given scene or situation, standard center-weighted metering systems would often not meet their requirements. Thus, the 9000 also features a spot metering capability combined with shadow and highlight biasing for unusual lighting situations. The photographer has a range of exposure options offered by the camera's multi-program, which includes Program Shift, Shutter Priority, Aperture Priority, and Manual modes. When set for programmed operation, Minolta's Automatic Multi-Program Selection (AMPS) selects one of three AE programs based upon the focal length of the lens in use.

Film speeds are automatically set with DX-coded film but can also be set manually in one-third stop increments from ISO 6 to 6400.

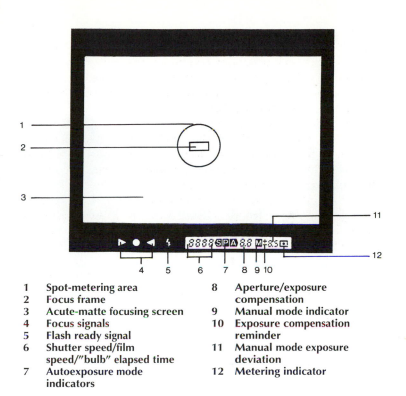

1	Spot-metering area	8	Aperture/exposure compensation
2	Focus frame		
3	Acute-matte focusing screen	9	Manual mode indicator
4	Focus signals	10	Exposure compensation reminder
5	Flash ready signal		
6	Shutter speed/film speed/"bulb" elapsed time	11	Manual mode exposure deviation
7	Autoexposure mode indicators	12	Metering indicator

The Maxxum 9000 uses the same Minolta AF lenses as the Maxxum 7000. These AF lenses are similar in size and weight to conventional manual focus lenses because the AF motor is located within the camera body. At the time these lenses were introduced, Minolta claimed that most of them could focus from their minimum focusing distance to infinity in less than one second. Today there are more than 38 Minolta AF lenses for the Maxxum series of cameras, in addition to many more offered by independent lens makers.

Using the Maxxum 9000

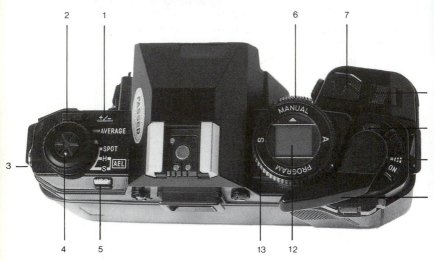

1 Exposure compensation key
2 Lock release
3 PC terminal
4 Back release/rewind knob
 and crank/metering selector
5 Film speed key
6 Shutter up/down control
7 Shutter release/operating
 button

8 Self-timer switch
9 Frame counter
10 Main power switch
11 Film advance lever
12 LCD panel
13 Exposure mode selector

Control Locations

The Maxxum 9000 is a hybrid of sorts. Most of its operating controls are located in their traditional positions, however they appear not as knobs and dials, but as electronic readouts and switches that send messages to the camera's electronic controls. Any experienced photographer can quickly learn how to use this camera. The switches were designed with a textured knurl for easy operation. The settings are visible in the viewfinder and on the LCD panel on top of the camera. Aperture settings are displayed in half-stops on the LCDs. For the standard 50mm f/1.7 lens, possible apertures range from f/1.7 to f/22. In Program and Aperture Priority modes, shutter speed settings are displayed in half-stops. In

these modes, shutter speeds that fall in between full stops will be selected automatically for more precise exposure, although only the closest half-stop will be displayed. In Manual and Shutter Priority modes, only full shutter speeds can be set. Speeds range from 1/4000 second to 30 seconds, plus "bulb."

The frame counter is located in front of the film advance lever. The large shutter release button, which also activates the meter and autofocusing systems when touched, is located on the top of the grip just in front of the frame counter. To conserve battery power, this button functions only when the main power switch is turned on. To the right of the shutter release is the self-timer switch.

Since the autofocus mechanism was designed to take priority over the manual focusing operation (when it is engaged), the customary location of focusing controls had to be altered on each lens. Although each lens has a wide, rubberized, knurled area, this is *not* used for focusing but for gripping or zooming (if it's a zoom lens). To manually focus, there is a narrow knurled ring at the very front of each lens that is only operable when the focus mode switch is set to Manual. None of the Minolta AF zoom lenses has a traditional one-touch knurl for both focus and zoom functions. However, since the autofocus mechanism is so rapid and accurate, one-touch zoom is hardly missed at all.

Main Power Switch
To operate the camera, you must move the main power switch to either the "ON" or the))) position. Switching to the))) position activates a beeping signal when your subject is in focus and when the self-timer is in operation.

Installing the Batteries
To install the batteries, first turn the main power switch off. Then push the battery compartment release on the base of the handgrip toward the back of the camera and pull out the battery tray. Place new AA-size alkaline or NiCd batteries in the tray making sure the plus (+) and minus (-) terminals are aligned as indicated. Slide the tray back into the handgrip until it locks into place.

Caution: *Never mix batteries of different types, brands, or ages, as this could result in bursting or leakage, which could damage the camera.*

To check the batteries' condition, turn the main power switch on and touch the shutter release button lightly. If the LCDs on the data panel or the LCDs in the viewfinder blink, the batteries' power is getting low and they should be replaced. Other indications of low power are: the shutter release will not operate, the aperture setting and shutter speed will not display on the LCD when the shutter release is pressed, and autofocus is either slow or will not operate. To prevent battery drain, remember to turn the main power switch off whenever the camera is not in use.

Battery performance is diminished in cold weather. It is wise to install fresh batteries before using your camera in frigid conditions. Keep a spare set in a warm pocket and alternate sets if the batteries in your camera seem to be losing power. The first batteries will probably regain power as they warm up. For prolonged cold-weather operation at 32° F (0° C) or lower, we recommend using NiCd batteries.

As long as the camera has fresh batteries, your exposure compensation, film speed, and manual exposure settings will be stored in the camera's memory. Whenever the battery tray is removed and replaced (regardless of whether new batteries are inserted), the following will occur: exposure compensation will default to +/- 0.0; film speed will default either to the film's DX-coded ISO setting or to ISO 100 for non-DX coded films; and manual exposure settings will default to 1/250 second and f/5.6.

Loading and Unloading the Film
To load film, first turn the main power switch on. Always load and unload film in subdued light or shade as bright sunlight can fog the film. Open the back of the camera by pulling the back release knob up while at the same time sliding the lock release to the right. Place the film cassette in the film chamber, then gently push the back release knob in. If it will not go in all the way, rotate the back release slightly in either direction to align the slotted shaft with the slot in the film cassette. Now place the tip of the film leader into the slot in the take-up spool *from right to left*. Be sure the end of the leader does not protrude from another slot. A perforation on the base of the leader must engage with a tooth on the take-up spool.

Gently hold the film against the sprockets with your left hand, release the shutter, and advance the film to be certain the film is

Be certain the film is wound tightly around the take-up spool. Also note that the teeth in the sprocket engage perforation holes on both edges of the film and that all the slack in the film is taken up before closing the back.

wound firmly around the take-up spool. Be sure the teeth in the sprocket are engaged with perforation holes on *both* edges of the film and that the slack is taken up.

Press the back cover shut until a click is heard. Trip the shutter and advance the film until the frame counter index points to "1." While the film is being wound, the center of the film rewind knob will rotate counterclockwise to show that the film is advancing correctly.

Caution: If the rewind knob does not rotate while you are advancing the film, the film is not engaged properly. Open the back cover and repeat the loading procedure.

Note: Before the film has been advanced to frame "1," the shutter will be set to 1/4000 second and the lens will be set at its minimum aperture. Also, the only function that will be operable is the camera's shutter release button. The camera will function fully only after the frame counter has reached "1."

The film advance lever swings away from the camera body, so you can easily slip your right thumb behind it. After making each exposure, advance the film by winding the lever its full 128° stroke (until the tip extends nearly straight out from the right side of the body). This can be done in one long stroke or several shorter strokes.

The film frame counter increases by one with each exposure. The film advance might stop before reaching the total number of exposures on any particular roll. *Never force the film advance lever.* If film does not advance when the lever is wound with a "normal" stroke, rewind the film.

Caution: *Before opening the camera back, always check the film window on the back of the camera to determine whether film is loaded. If a cassette is visible, check to see if the film has been completely rewound by rotating the rewind knob clockwise until it turns freely. Never touch the sensitive shutter curtain or film pressure plate.*

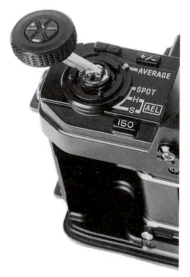

When you reach the end of a roll of film, press the rewind release button on the right-hand side of the camera's base. Pull the rewind crank up, then let it drop to one side so that it is off-center. Rotate the crank clockwise and wind the film completely into the cassette until the crank turns without resistance. To open the back cover, pull the back release (which is also the rewind crank) up while simultaneously sliding the lock release hidden underneath it to the right. The cover will spring open and you can remove the cassette.

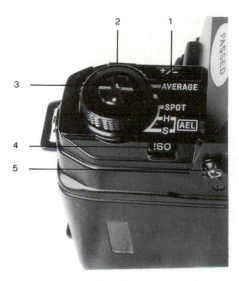

1 Exposure compensation key
2 Lock release
3 Back release/ rewind knob and crank/metering selector
4 Film speed key
5 Eyepiece adjustment dial

Setting the Film Speed

When any DX-coded film cassette is loaded and the film is advanced to the first frame, the camera automatically reads and sets the ISO film speed. This film speed is automatically displayed on the LCD panel on top of the camera. If the setting displayed is the one you want to use, just touch the shutter release button and you are ready to make pictures.

To set the film speed manually to another ISO rating, press the film speed key marked "ISO" to the left of the prism and continue to hold it down. Then move the shutter up/down control in front of the LCD panel to increase or decrease the ISO value displayed on the LCD. Each time the control is moved, the setting will change by one-third step. After obtaining the desired film speed, release the ISO key. You can check it at any time by merely pressing the ISO key.

When using non-DX-coded films, the film speed setting will be automatically reset anytime the battery holder is removed and reloaded. The default setting of ISO 100 will then blink rapidly on the LCD as a warning, and the shutter release will not function. Before the camera can again be used, the ISO film speed must be reset manually. For regular DX-coded films, if the displayed

setting is correct, just touch the shutter release button and the camera can be operated again.

Changing Lenses

To change lenses, press in the lens release button to the left of the lens mount, turn the lens counterclockwise as far as it will go, then lift the lens straight out of the body. If the camera is switched on, the LCD will show "– –" when the lens is removed. To attach another lens, align the red index on the lens barrel with the red index on the camera's lens mount. Seat the lens into the lens mount and turn it clockwise until it locks into place with a click.

Note: When attaching or removing lenses, never touch anything inside the camera, especially the electrical contacts and the mirror. To protect the lens contacts and elements, always attach a body cap on the rear of the lens and a lens cap on the front of the lens whenever carrying or storing it. The camera's mirror is particularly vulnerable. Dust specks on its surface will not affect meter readings or picture quality since the mirror swings out of the way prior to exposure.

Exposure Modes

Program Mode

Program ("P") mode is ideal for situations when you just want to shoot pictures without having to set or adjust the camera's aperture or shutter speed. This mode features Automatic Multi-Program Selection (AMPS), which matches the exposure program to the focal length of the lens in use, and Program Shift. In AMPS, aperture and shutter speed are set automatically and displayed both at the bottom of the viewfinder and on the LCD panel. (In low lighting situations, the LCD panel in the viewfinder automatically illuminates.) To select Program mode, just rotate the large exposure mode selector knob to align "PROGRAM" with the index at the top of the LCD panel.

In AMPS one of three programs is automatically selected to match the lens' focal length; in other words, it is not possible for you to select a program manually. For lenses shorter than 35mm, the program will select the smallest aperture practical to obtain

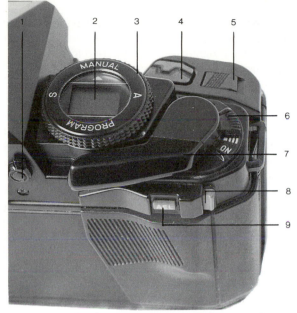

1	Eyepiece shutter knob	5	Self-timer switch	
2	LCD data panel	6	Main power switch	
3	Exposure mode selector	7	Film advance lever	
4	Shutter release/operating button	8	Multiple exposure button	
		9	Autoexposure lock button	

the maximum depth of field. For 35mm to 105mm lenses, the program will select faster optimum shutter speeds and hence, wider apertures. For telephoto lenses longer than 105mm the program will select a minimum shutter speed of 1/250 second to minimize any blur due to camera shake; this will also result in wider apertures. The program will automatically change as any Maxxum AF zoom lens is zoomed from one focal length to another.

Note: If the light level is outside the metering range (too dark or too bright), the metering indicator on the far right of the base of the viewfinder will blink as a warning that the exposure may not be correct. If both the shutter speed and aperture displays blink, the appropriate aperture-shutter speed combination is not available for use. In that case, you must shift to another combination using Program Shift.

Program Shift: Many times photographers want to use a different shutter speed or lens aperture than was selected by the camera's internal computer. Program Shift can be used to temporarily select an alternate aperture-shutter speed combination to achieve a desired effect. Shifting the program *does not* change the exposure. It merely changes the combination of aperture and shutter speed settings used to reach an equivalent exposure. For example, if you shift the program to a faster, action-stopping shutter speed, the lens will automatically be set to a larger aperture so that the same amount of light will expose the film.

Shifting the program is simple. Just move the shutter or aperture up/down control until the desired shutter speed or aperture setting appears in the viewfinder or the LCD panel. These settings will change in half-stop increments, and the "P" in the viewfinder will blink to indicate when Program Shift is in use. Before an exposure is made, the shifted setting will be held for ten seconds after lifting your finger from the shutter release button. After the exposure has been made, Program Shift is canceled as soon as your finger is lifted from the shutter release button.

Note: To make several exposures at the same shifted program setting, just keep your finger on the shutter release button between exposures. When using zoom lenses, we recommend that you shift the program *after* zooming, because the camera will automatically make another AMPS exposure selection after the lens is zoomed.

Aperture Priority Mode
Aperture Priority ("A") mode allows you to select a specific aperture. The camera will then automatically select the shutter speed necessary to obtain the proper exposure. This mode is used when it is desirable to control the depth of field (range of sharpness) within a photograph. In a landscape for instance, you may want the entire scene to be sharp from foreground to infinity. To achieve this, set a small aperture (large f/number) such as f/16.

When shooting street scenes and landscapes, maximum depth of field is often desirable for documenting as much information as possible. ⇨

Conversely, a large aperture (small f/number) such as f/2.8 will minimize or shorten the depth of field, so that only a narrow plane will be in focus. This is beneficial when you want only a specific subject or area in the photograph to be rendered sharply and the background softly blurred.

To set this mode, rotate the exposure mode selector knob to align the "A" with the index above the LCD panel. A small pointer will appear next to the aperture setting on the LCD, indicating that this f/number can be set manually. Move either the aperture or shutter up/down control until the desired aperture is shown on the LCD and viewfinder. Each time an up/down control is moved, the aperture will change by one half-stop. The aperture setting will change rapidly when the control is held down in either direction. Any aperture available from those shown on the range limit on the lens can be set.

Note: The shutter speed displays on the LCD panel and inside the viewfinder will blink when the speed required is outside the range of possibility, given the aperture selected. If this happens, change the aperture until the blinking stops, indicating that you have selected an aperture for which a shutter speed can be set. For instance, if "4000" blinks, set smaller apertures, and conversely, if "30" blinks, set larger apertures until the blinking stops.

Shutter Priority Mode

To select Shutter Priority ("S") mode, rotate the exposure mode selector knob to align "S" with the index mark above the LCD panel. A small pointer will appear next to the shutter speed setting on the LCD to indicate that it can be set manually. To change and set the shutter speed, move either the shutter or aperture up/down control until the desired shutter speed is shown on the LCD panel and inside the viewfinder. Any available shutter speed from 1/4000 second to 30 seconds can be set.

Each time an up/down control is moved, the shutter speed will change by one full speed or step. Again, if the up/down control is held in either direction, the speeds will change more rapidly. After setting the desired shutter speed, the camera will automatically select the aperture required to obtain the correct exposure.

Note: Do not use the "bulb" shutter speed setting, which will appear after the 30 second setting, in these semi-automatic modes. "Bulb" can only be used in Manual mode. If the lens' maximum aperture (e.g., f/2) blinks on the LCD, set slower shutter speeds until the blinking stops. Conversely, if the lens' minimum aperture (e.g., f/22) blinks, set faster shutter speeds until the blinking stops. If the prevailing light level is outside the metering range, the metering indicator at the base of the viewfinder will blink to warn you that the exposure may not be correct.

Metered Manual Mode

In Metered Manual ("M") mode, the photographer has full control over all creative aspects of every photograph. The final exposure can be based upon the camera's internal TTL meter, a handheld light meter, or based on prior experience. Any available shutter speed or aperture can be set. Both settings will be displayed in the viewfinder and on the LCD panel. To use this mode, rotate the exposure mode selector knob to align "MANUAL" with the index mark above the LCD. Small pointers will appear next to both the shutter speed and aperture settings on the LCD, indicating that both can be set manually.

Use the aperture up/down control to the left of the prism to set the aperture in half-stop increments. Use the shutter up/down control in front of the exposure mode selector knob to set the shutter speed in full steps.

```
60          5.6 M⁺²  ☐
```

```
500         5.6 M⁻¹  ☐
```

When the camera is in Manual mode, the viewfinder displays the amount of exposure compensation you have set. +2 indicates that you have set two stops more than what your camera's TTL meter senses is necessary for a correct exposure. -1 indicates that you have set one stop less than the meter has calculated.

In Manual mode, the camera's LCD at the base of the view-finder will provide information on how the manual settings differ from the setting the camera would recommend in either automatic mode. A large "M" will appear in the viewfinder to indicate that you are in Manual mode. Directly to the right of the "M," an exposure deviation indicator will appear. To set the camera to an exposure based on the camera's TTL meter, just adjust the up/down controls as suggested by the indicator value. For instance, if a "-0" or "+0" appear next to the "M," the exposure is set within +/- one quarter-stop of the meter's recommended exposure. If "+2" is displayed, this indicates the exposure is set for two stops greater than what the system recommends for a "normal" exposure. You may choose to match the suggested setting by stopping the setting down by two steps, or you might choose to leave the setting you origi-nally selected, intentionally increasing exposure to render high-lights extremely white. Similarly, if "-1" is displayed, the exposure set is one stop less than what is recommended. Again, this gives you the chance to adjust your settings to the meter's recommen-dation or intentionally decrease exposure, which will render shadow areas darker. Either way, the camera has given you infor-mation on which you can base your decision for making a correct exposure.

Note: If the light level is outside the camera's metering range, the metering indicator at the far right of the bottom of the viewfinder will blink as a warning that the exposure may not be correct. *You*

can still make an exposure, but it probably will not be correct. If the exposure compensation key is set when the camera is in Manual mode, the +/- symbols will *not* appear in the LCD panel, but the values indicated for normal exposure will include the compensation value. For example, if the normal exposure were 1/60 second at f/5.6 when the exposure compensation is set to +1.0, the meter will indicate the normal exposure is either 1/60 second at f/4 or 1/30 second at f/5.6.

The "bulb" shutter setting can be used only when the camera is in Manual mode. Use the shutter up/down control until "bulb" appears (right after 30) on the shutter speed portion of the LCD panel. Set the aperture as desired, then focus the lens, and release the shutter.

For long "bulb" exposures, the camera should be mounted on a tripod or other sturdy support. It is further recommended that the optional Remote Cord RC-1000S (short) or RC-1000L (long) be used to prevent the camera from vibrating while you press down and hold the shutter release button. The camera's shutter will remain open for as long as the shutter release button on the camera or the switch on the remote cord is depressed. To assist in judging the actual exposure, the elapsed exposure time in seconds will be shown on the LCD panel. After 99 seconds, the counter will return to "0" but will still continue counting.

Note: The self-timer will not operate in the "bulb" setting. The maximum exposure time in "bulb" depends upon the batteries' capacity. With new alkaline batteries at room temperature, you are limited to approximately eight hours of exposure.

Focusing

Autofocus

The Maxxum 9000's autofocus system has both Continuous and Single-Shot autofocus capabilities. To activate the camera's autofocus function, set the focus mode switch to "AF." Continuous autofocus is activated as soon as the shutter release is touched. As long as your finger rests on the shutter release button, the camera will continuously adjust the focus for whatever subject appears

within the rectangular focus frame in the center of the viewfinder. Action of moderate speed can be followed with continuous auto-focus as long as the primary subject is within the focus frame and the release button is lightly depressed. A green focus signal will light in the viewfinder and the camera will beep (if the power switch is set to)))), indicating that focus has been achieved. You can now make the exposure by fully depressing the shutter release.

Note: Continuous autofocus cannot be activated while wearing gloves, as the camera's touch switch will not respond.

To lock focus on a particular subject for single-shot autofocus, point the focus frame at the area you would like to have in focus. Focus signals at the left of the base of the viewfinder help you achieve correct focus. If the subject area within the focus frame is not in focus, one of two red triangular LEDs will point in the direc-tion that focus must be shifted. If only the triangle on the left lights, the subject is too close to be focused and you should move fur-ther away or change lenses. A green LED in the viewfinder will light when proper focus is achieved. The camera will also beep if the main power switch is set to))). When this happens, press the shutter release down halfway to lock focus at that distance. Focus will be held there as long as the shutter release continues to be pressed down halfway. You can now recompose the picture, if necessary, and make the exposure.

If both red triangles light and blink, either the illumination is too low or the subject cannot be focused in autofocus mode. Prob-lematic subjects for any autofocusing system include subjects with little or no contrast (like a blank wall), subjects behind bars, or subjects composed entirely of horizontal lines such as venetian blinds. If illumination is too low, you can use a Minolta Maxxum flash or switch to manual focus mode. If contrast is too low or there are subjects at various distances within the sensor range (such as a lion in a cage), you can either lock focus on another subject equally distant from your camera as the subject you wish to photo-graph, or you can focus manually.

Note: The shutter can be released at any time, whether the sub-ject is in focus on not, so be sure the camera is focused on what you want prior to actually releasing the shutter to make a picture.

Manual Focus

To activate manual focus mode, set the focus mode switch to "M." In this mode, the LED signals inside the viewfinder will still operate to serve as a reminder and indication of which way to turn the lens focusing ring. Once again, a green dot will light to indicate that the area within the focus frame is in proper focus. The camera will also beep if its main power switch is set to the))) position. If both red triangles blink, the subject must be focused visually on the acute-matte screen, without "auto-assist." Simply turn the narrow focusing ring on the front of the lens until the subject appears sharpest in the viewing screen. If only one of the red triangles is lit, turn the focusing ring in the same direction as the arrow is pointing.

In certain situations it may be desirable to set the focus manually in order to focus and photograph at a specific distance. Typical situations include making long exposures when it is too dark to focus visually, taking an action photo by prefocusing the lens at a certain distance, or tripping the shutter when the subject reaches a certain distance from the camera. To do this, set the focus mode switch to "M," estimate the distance from the camera to your subject, then turn the focusing ring until the index line aligns with the corresponding distance on the lens' scale.

Focusing with Infrared Film

If you use infrared film, remember that it does not have the same point of focus as conventional films, so you must compensate the focus manually. You must increase the lens-to-film distance in order to make an in-focus exposure. First, attach a filter if needed, and focus the subject as you normally would (using either autofocus or manual focus, as the situation requires). Note the distance on the lens' focusing scale, then switch the camera's focus mode to "M" (if it's not already). Turn the focusing ring until the distance originally focused on is opposite the small red dot on the lens' focusing scale. This must be done when focusing at all distances, including infinity.

Metering Options

The Maxxum 9000 offers two types of metering: Center-Weighted Average and Spot. Center-weighted average metering is the norm on the Maxxum 9000 and should suffice for most situations. Spot metering is useful for precise metering of specific subjects.

To select the appropriate metering sensitivity, turn the knurled metering selector surrounding the back release/rewind crank to Average or Spot. The viewfinder's LED informs you as to which type of metering you have selected. A rectangular LED box at the far right side of the viewfinder indicates average metering is in use. When the same box has a black dot inside it, spot metering has been selected.

The meter is activated by lightly touching the shutter release. The meter will remain on for ten seconds after you remove your finger from the shutter release, to provide time for you to make other settings.

Metering controls for the Maxxum 9000 are located on the left side of the camera.

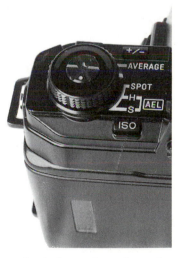

Center-Weighted Average Metering

For center-weighted average metering, exposure is based on the average of light reflected within the entire viewfinder frame, with additional emphasis on the light readings from the center of the frame. Average metering produces consistent, reliable results in most situations.

Whenever you need to meter an area that is off-center (such as when a person is beside a bright window, which would bias an

average reading), first center the subject in the viewfinder. Take a reading by pressing and holding the AE lock button (below the film advance lever) to lock and hold this exposure value while recomposing the frame. The photo will be exposed for the subject instead of the window.

Spot Metering
Spot metering measures the light that falls within the small reference circle in the center of the viewfinder. This area comprises only 2.7 percent of the total image. When a precise measurement of a specific subject is desired, center-weighted metering would probably not give the best exposure. This type of selective metering is only recommended for certain situations—when the main subject is not centered and when the brightness level between the subject and background is exceptionally high. A spotlit performer on a stage or a backlit friend on the beach are two typical examples. Selective spot metering readings should be made on a midtone value (such as a person's tanned face, a tree or foliage, or any neutral-toned object) particularly when the lighting contrast is high.

To do this, first set the metering selector switch to the "SPOT" position. Position the camera's viewfinder so that a midtone area fills the small circle in the center of the screen. If the metered area is not going to remain in the center of the picture in the final framing and you are in "P," "A," or "S" mode, just press the AE lock button to hold the reading, recompose the frame, and make the exposure. The AE lock button must be held continuously in order to retain the exposure setting. It is slightly recessed, so it is difficult to press accidentally while holding the camera.

Spot metering can be used in Manual mode as well, however there is no need to lock in the exposure settings. Meter on an 18 percent gray area and set the exposure. Then recompose and take the picture, ignoring warnings of inaccurate exposure created by the background that is now included in the frame.

Highlight and Shadow Biasing
The Maxxum 9000 gives you the option of further refining your spot metering by selecting either "H" (Highlight) or "S" (Shadow) on the metering selector. These two options are used to accurately meter a subject consisting primarily of bright (highlighted)

subjects or dark toned (shadowed) subjects. If you select "H" or "S," you *must* press the AE lock button while making the exposure.

Note: When making either highlight or shadow-based exposures in "P," "A," or "S" modes, the AE lock button must be pressed in and held while releasing the shutter. Otherwise the spot meter will set the exposure to produce a midtone value even if the metering selector is set at the "H" or "S" setting.

In brief, the metering system will increase exposure at the "H" setting to produce clean, white tones. At the "S" setting, it will decrease exposure to produce rich blacks, while conventional metering would produce gray in both cases. Naturally, you can achieve a similar effect yourself by adjusting the shutter speed or aperture in Manual mode or setting a + or - exposure compensation factor in one of the AE modes.

Exposure Compensation
The exposure compensation key can be used to help produce better exposures of difficult subjects. The camera's autoexposure system meters the light with the assumption that the subject is 18 percent gray. If it is in fact either brighter or darker than that, the meter will still create an exposure setting that makes the subject 18 percent gray. Exposure compensation is an easy way to intentionally correct the exposure in half-stop increments between +4.0 and -4.0.

For instance, when the background is much brighter than the small main subject or the scene is predominantly bright, as in a snow-covered landscape, the exposure compensation key could be set between +0.5 and +2.0 stops. This will render the highlights brighter, and the subject will be exposed more accurately.

When the background is much darker than the main subject (such as a person in white standing in front of a deeply shaded woods) or you are photographing a scene composed predominantly of dark tones, (such as the proverbial black cat in a coal bin), you might set the exposure adjustment between -0.5 and -2.0 stops to render it more accurately, rather than gray. Exposure compensation in this range could also be used for spotlit subjects on stage or at a circus performance.

To set exposure compensation, press and hold the exposure compensation key (marked "+/-" and located just above the rewind knob). Next, move the shutter up/down control until the desired adjustment value appears in the viewfinder data panel. Set minus (-) numbers to decrease exposure, rendering dark subjects dark. Set plus (+) numbers to increase exposure, rendering bright subjects bright.

Whenever an exposure adjustment is set in "P," "A," or "S" mode, the "+" or "-" symbol appears on the LCD panel, and the adjusted value will blink in the viewfinder display. The exposure deviation indicated in the viewfinder includes the exposure compensation value set and it can be checked at any time by pressing the exposure compensation key. In "M" mode, no indication will appear on the LCD panel when exposure compensation is set.

Some professionals like to intentionally underexpose their color transparency film by 0.5 to 1.0 stop for better color saturation. Using the exposure compensation function is the easiest way to do that.

Finally, exposure compensation can also be used to "bracket" a shot when you are uncertain as to how a scene, such as a sunset, should be exposed. Bracketing is done by making a series of photos in half-stop increments, thus capturing a variety of solutions to the same scene.

Note: Be sure to reset the exposure compensation value to "+/- 0.0" when you are finished using this function.

Other Controls

Depth-of-Field Preview
The Maxxum 9000 offers the professional photographer a depth-of-field preview button, which allows you to stop the lens down to the set aperture in order to visualize which areas within the frame will be in focus once the picture is developed.

Normally, the scene in the viewfinder is seen through the widest aperture, offering you a bright viewing screen, allowing you to more easily focus and compose your photograph. The depth-of-field preview can be used in all exposure modes. First, advance the film and focus on the main subject. If you are in "A" or "M"

mode, set the desired aperture. If you are in "P" or "S" mode, just meter the scene as you normally would. Simply press the preview switch (found just below and to the left of the shutter release button) partway down and release it. When this switch is activated, the lens will close down and lock at the set aperture. The viewing screen will darken, so give your eye time to adjust. This darkness will not affect your actual exposure. Now you can visually judge the range of apparent sharpness in the scene. The letter "F" next to the aperture reading will blink in the LCD panel while the depth-of-field preview switch is in use.

Note: When the lens is closed down, autofocus will not operate, and it is not possible to change the aperture setting.

To disengage depth-of-field preview, press the switch all the way down and release. This will allow you to adjust the aperture setting. Depth-of-field preview will also disengage when the shutter is released.

Self-Timer
To activate the self-timer, slide the self-timer switch to the right. A red mark will be revealed under the switch indicating that it is on. Focus and meter the picture as you normally would, then close the eyepiece shutter by turning the small knob to the right of the eyepiece clockwise. Now press the shutter release down completely. A ten-second countdown will start. The self-timer LED on the front of the hand grip will begin to blink slowly for eight seconds, then rapidly for one second. During the last second the LED will remain on, indicating that the shutter is about to fire. After making your pictures using the self-timer, you must actively turn it off by sliding the switch back to the left, toward the shutter release button. If you find you need to cancel the self-timer after it has engaged, simply slide the self-timer switch back toward the shutter release button.

Note: To activate the camera's audible signal, which will beep simultaneously as the LED blinks, set the main power switch to))).

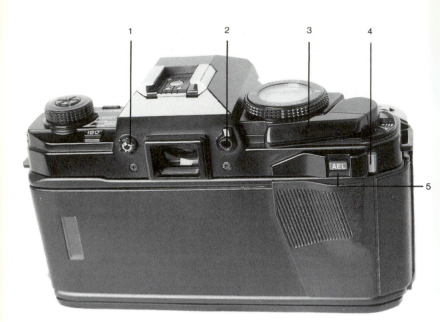

1	Eyepiece adjustment dial	4	Multiple exposure button
2	Eyepiece shutter knob	5	Autoexposure lock button
3	Film advance lever		

Multiple Exposure Button

A button on the back of the Maxxum 9000 (under the film advance lever, next to the AE lock button) permits the shutter to be cocked without advancing the film so that multiple exposures can be made. The frame number will not advance until film is actually advanced.

To use this feature, make your first exposure. Press in and hold the multiple exposure button, then recock the shutter by operating the film advance lever. Repeat this procedure to make additional exposures on the same frame of film. After making the final exposure, release the multiple exposure button. Wind the film advance lever normally to advance the film to the next frame and recock the shutter.

Determining the proper exposure for multiple exposures on a single frame differs from metering for single exposures. Situations

vary with subject matter, lighting conditions, and your intended final results, but as a general guide try the following.

To make two exposures of evenly illuminated subjects that fill most of the image area, set exposure compensation to -1.0. This decreases the exposure for each image exposed by one-half, so the final double exposure should be correct. To expose four evenly illuminated images on one frame, set the exposure compensation to -2.0, and so on. For multiple exposures of non-overlapping subjects positioned against a dark background, exposure compensation is generally not necessary.

Eyepiece Shutter

The eyepiece shutter prevents stray ambient light from entering the camera through the eyepiece, thus affecting the metering and resultant exposure. You should close the eyepiece shutter whenever you are taking pictures while your eye is not against the eyepiece. Such situations might include remote-control photography, self-timer operation, or long exposures with the camera on a tripod or other support. To close the eyepiece shutter, turn the small knob above and to the right of the eyepiece clockwise.

Eyepiece Adjustment Dial

The small rotating knob to the left of the eyepiece enables near- or farsighted users to make dioptric adjustment to the eyepiece for clearer viewing without glasses. The dioptric adjustment range is from -3 to +1 diopters. To adjust, turn the dial while looking through the viewfinder until the information within the viewfinder's focusing frame appears sharpest. If additional correction is needed, Minolta offers the Minolta Eyepiece Corrector 1000, which can be attached to the eyepiece.

Accessory Shoe and PC Sync Terminal

When using a Minolta Maxxum flash, such as the 2800AF or 4000AF, which attaches to the camera's hot shoe, X sync is automatically set. Minolta's TTL direct autoflash metering operates in all modes. In "P" mode the X-sync speed of 1/250, 1/125, or 1/60 second is set depending upon the prevailing light level. In "A" mode the X sync is automatically set at 1/250 second, and any aperture can be set on the lens. In "S" mode, any shutter speed of 1/250 second or slower can be selected, and the aperture is set

automatically at f/5.6. In "M" mode, any shutter speed of 1/250 second or slower can be selected and any aperture can be set.

A handy PC sync flash terminal is located on the top left of the camera. This will accept PC-type sync cords from studio and other flash units that do not have a hot shoe contact. When operating a flash using the PC terminal, the camera's X sync must be set manually to any speed of 1/250 second or slower. The camera's internal TTL flash metering does not function with such units. To determine the proper exposure setting, refer to the Guide Number (GN) for the flash/ISO combination or use a flash meter. Large studio-type flash units have capacitors that require more time to discharge at full power. Shutter speeds should be set to 1/125 second or slower to assure full exposure when using this type of flash unit.

System Accessories

Using a Tripod

For longer exposure times, when holding the camera by hand could result in blurred images, mount the camera on a tripod using the threaded socket on the camera's base. Never overtighten the tripod screw when attaching the camera, and be certain the tripod screw is not longer than one-quarter inch (5.4 mm), or the camera's interior could be damaged.

Optional remote cords RC-1000L (long) or RC-1000S (short) can be used to gently trip the shutter without your having to touch the shutter release button, risking camera vibration. The terminal on the end of the remote cord fits into a small electrical socket at the lower left corner of the camera body. Close the eyepiece shutter before making the exposure to avoid stray light from entering and causing erroneous meter readings. To make an exposure, just depress the switch on the remote cord.

You can also lock the remote shutter release switch on when making long exposures in "bulb" setting (when photographing fireworks or lightning, for instance). To do this, simply push the switch in and slide it up until the exposure has been made for the desired duration.

Other Accessories

Many accessories were introduced with the Maxxum 9000. A popular item was an external Motor Drive MD-90 with single frame, 2, 3, and 5 fps continuous film advance. The film can also be wound and rewound with the MD-90 Motor Drive. This motor drive offers focus-priority shutter release as well. Since professionals tend to take a high percentage of vertical pictures, Minolta placed a handy vertical shutter release button on the MD-90 Motor Drive. Power is provided by readily available AA-size batteries, which operate efficiently in a wider temperature range than the lithium batteries commonly used in most newer AF SLRs.

Program Back Super 90 offers automatic bracketing (to vary exposure from one frame to the next) and exposure data imprinting. Program Back 90 is similar to the Super 90, but is less full-featured. The 100-Exposure Back EB-90 has Super 90 capabilities with the added capacity of being able to expose up to 100 frames.

The Wireless Controller IR-1N Set permits cordless remote control photography from up to 200 feet (61 m) away and is recommended for use with the MD-90 for making photographic sequences. Data Receiver DR-1000 can receive data wirelessly from the Minolta Flash Meter IV to set the camera from up to 23 feet (7 m) away. Control Grip CG-1000 permits cordless off-camera flash with the Maxxum Flash 2800AF or 4000AF. Optional flash units include the Maxxum 1800AF, 2800AF, and the 4000AF.

More information on these and other Maxxum accessories can be found in the chapter *Maxxum Accessories.*

Minolta Maxxum 9000 Specifications

Type: 35mm SLR with autofocus and multi-mode exposure control.

Lens Mount: Minolta A-type, accepts all Minolta AF lenses.

Autofocusing System: TTL phase-detection type.

AF Sensitivity Range: EV 2 to EV 19 at ISO 100 film in ambient light.

Metering: TTL center-weighted averaging type by compound silicon photocell (SPC) at bottom of mirror box; spot metering also available by using center portion of same SPC.

Autoexposure Range: EV -1 to EV 20 with ISO 100 film, 50mm f/1.4 lens.

Exposure Modes: Program AE, Shutter Priority AE, Aperture Priority AE, Metered Manual.

Exposure Compensation: Compensation factor can be set to +/- 4 EV in half-stops.

TTL Flash Metering: Direct TTL autoflash metering by same SPC. Operates in all modes with dedicated flash, shutter automatically set to X sync of 1/250 second.

Shutter: Electronic vertical-traverse focal plane; stepless range of 1/4000 second to 30 seconds, plus bulb.

Operating Button/Shutter Release: Touch-switch activates metering and continuous autofocusing; meter stays on for 10 seconds after finger is lifted; pressing halfway down holds focus; pressing down all the way releases shutter.

Film Speed Range: ISO 6 to 6400.

Film Transport: Manual film advance; film advance lever has 30° offset angle with 128° movement in single or multiple strokes. Manual rewind by crank.

Viewfinder: Eye-level fixed pentaprism; built-in eyepiece correction adjustable from -3 to +1 diopters; field of view 94 percent of frame area; magnification 0.81x with 50mm lens at infinity.

Data Display: Top LCD panel shows shutter speed, aperture, exposure adjustment, film speed, frame number, "bulb" operation elapsed time.

Viewfinder Display: LCDs show exposure mode, metering mode, shutter speed, aperture, exposure adjustment, film speed, exposure deviation in Metered Manual mode.

Preview Switch: Used for checking depth of field; operates in all four exposure modes.

Multiple Exposure Button: When pushed in, shutter can be recocked without advancing film; frame counter does not advance during use.

Other: PC sync terminal, eyepiece shutter, remote-control terminal, film window, changeable focusing screen.

Power: Two AA-size 1.5v batteries power all operations.

Dimensions: 2-7/8 x 3-5/8 x 5-1/2 in. (53 x 92 x 139 mm).

Weight: 22-3/4 oz. (645 g) without lens and batteries.

Minolta Maxxum (Dynax) 7000i

Minolta Maxxum (Dynax) "i" Series

The second generation of Maxxum cameras was designated with the suffix "i" for "intelligent." (These cameras are called the "Dynax i" series in markets outside North America.) After the original Maxxum cameras had been on the market for about three years, Minolta engineers refined the autofocus concept. As a result of their efforts, the first two models of the Maxxum "i" series, the 7000i and 3000i, were introduced in the spring of 1988. This coincided with the celebration of the sixtieth anniversary of the founding of the Minolta Corporation. It was named European Camera of the Year '88–'89. The 5000i was introduced mid-year in 1989, while the most advanced model of this series, the Maxxum 8000i, was launched early in 1990.

With the original Maxxum system, Minolta offered cameras and autofocus lenses plus a multitude of dedicated accessories. These included dedicated electronic flash units, program backs, electronic remote releases, wireless controllers, focusing screens, and more. All of the original Minolta AF lenses introduced in 1985 are fully compatible with later generations of Maxxum cameras. Most of the original accessories are also fully compatible with the "i" series cameras except the flash units. This is due to the exclusive Minolta dual-rail flash shoe found on the later Maxxum models. And because the body shape is different, the databacks are not compatible either.

Minolta Maxxum 7000i

New Styling, New Features
A visual comparison of the Maxxum 7000i with the original Maxxum 7000 clearly shows many changes and improvements in the "i" version. In terms of styling, the 7000i has rounded curves instead of the squared-off, flat, angular body of the original model. The AF illuminator function was built into the body of all "i" series

cameras (except the 3000i) for improved autofocus performance in extremely low light. (The original Maxxum 3000, 5000, 7000, and 9000 cameras did not include this illuminator. However, it was available on the system's flash units.) The infrequently used control buttons (for setting ISO with non-DX coded cassettes, self-timer, mid-roll rewind, and a new program card adjustment) are concealed under a card door on the right side of the body.

Practically all of the primary operating controls were refined in shape and relocated for more convenient access. For instance, the former models' two up/down controls located behind the shutter release and on the side of the lens mount have been consolidated into one very accessible sliding switch in front of the shutter release button. There are two buttons on the top left for mode and function changes and one much larger rectangular "P" button on the right for instant return to Program mode. (This also changes the autofocus back to the normal wide-focus area and film advance

to single-frame.) The on/off switch is now on the top left of the camera instead of the top right.

A larger, angled LCD data panel on the top right of the body is far more visible from the photographer's viewpoint above and behind the camera. The LCD panel is considerably larger and tilted for easier visibility. The increased quantity of data displayed is very legibly positioned within the panel. The LCD panel is illuminated for easy reading in dim lighting, and the battery status is displayed every time the camera is turned on.

The hot shoe on top of the pentaprism has two guide slots to ensure a more positive fit for the series of dedicated electronic flash units designed specifically for the "i" series cameras. When attached, the flash unit's auto-locking mechanism locks the unit in place so it cannot be accidentally removed. It is easily detached by depressing a button on the flash unit.

Maxxum "i" Series Advancements
Autofocus System: The Maxxum "i" series cameras introduced significant improvements in the operational speed of the autofocus mechanism making it the fastest AF system available at the time. These included a wider autofocus detection area, three CCD (Charge-Coupled Device) sensors (one vertical sensor on each side of the central horizontal sensor), and a "predictive" capability for better sensing and tracking of moving subjects within the focus area. The built-in AF illuminator near the top of the lens facilitates accurate autofocusing on subjects up to 30 feet (9 m) away in total darkness.

What is quickly apparent about this new camera when you put it to your eye is the significantly faster operation of the autofocus mechanism and the wider focusing field. The wide focus area in the 7000i was said to be 12 times larger than that found on other AF cameras available at the time. This area is delineated in the finder by two brackets on either side of a central circle etched on the screen. The smaller rectangle in the center indicates a central focus detection area that can also be selected.

The autofocus module contains a triple CCD sensor array—two vertical sensors on the edges of the wide focus area and one horizontal sensor in the very center of the viewfinder. This provides enhanced autofocus sensitivity on a wider range of subjects, including off-center and moving subjects. When any part of the

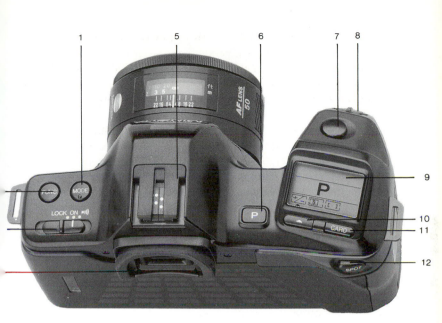

1	Exposure mode button	7	Shutter release button
2	Function adjustment button	8	Up/down control
3	Main power switch	9	LCD data panel
4	Eyepiece cup	10	Function selector key
5	Accessory shoe	11	Card on/off key
6	Program reset button	12	Spot button

subject is within the boundaries of the wide focus area, the focus is continuously adjusted. This is a more advanced and practical method than that utilized on earlier autofocus cameras.

Predictive Autofocus: Because it is a significant enhancement, let's consider some specifics of predictive AF technology. This system actually calculates the speed and direction of a moving subject and continues to adjust the focus up to the moment of exposure. Readings are made up to 30 times per second to monitor focus when the shutter release is partially depressed; this data is fed into the AF computer for an instant response. The primary advantage is that the system compensates for time lag—the delay

between pressing the button and the instant of exposure. Time lag varies between cameras, but predictive AF sets focus to the point the subject will reach at the moment of exposure, resulting in sharper photos.

The wide-area AF sensor field is also advantageous to the camera's predictive AF capability. Earlier autofocus cameras had a small central detection area that required precise positioning. This was not a problem with a large subject, but it did create problems in action photography. If a small subject drifted off-center, focus was lost. The shutter would not release, saving you from making an unsharp picture. The wide focus area in the "i" series cameras allows the camera to be more forgiving of moving subjects that stray from dead center.

It could also be very frustrating for photographers using earlier autofocus cameras to photograph subjects moving toward or away from the camera. The problem is far less likely to occur with the 7000i, thanks to its wide focus detection area. Combined with effective predictive AF, fast-action subjects are easily within the scope of this camera.

Metering Options: Integrated multi-pattern metering reads the entire scene, optimizing exposure for the subject in focus. By intelligently evaluating the light pattern of a scene, it produces more accurate exposures in common situations such as a mottled, light landscape with a bright sky.

A spot meter override is accessible by pressing and holding in the "SPOT" button at the back of the right side grip. When the button is depressed, reflectance is measured in a small central circular area of the finder (about 2.3 percent) and retained until the button is released. Precise spot metering can be performed in all four exposure modes. To visually alert the photographer of the selective metering capability, a small spot appears in the viewfinder when the "SPOT" button is depressed. When the camera is switched to manual focus, exposure determination is automatically shifted to center-weighted averaging with scene contrast evaluation.

Other Improvements: Other notable improvements in the more advanced models of the "i" cameras include a unique new Creative Expansion Card system (usable in all models except the 3000i)

for customizing various functions to suit individual users' preferences. Categorized by function, the optional cards include feature cards for advanced camera control, special application cards for fully automatic operation, and customized function cards to alter the camera functions to suit your specific requirements.

To use any of the cards, just open the card door on the right side of the camera and insert the small card into the slot. The card is visible through a window, and a key turns it on or off; the application of the data stored on the card is automatic when it is turned on. For additional information about the Creative Expansion Cards see the chapter *Maxxum Accessories.*

The speed of the built-in, totally automatic motor drive was increased to a maximum rate of 3 frames per second (fps) on the 7000i and 8000i cameras. All "i" cameras use lithium batteries instead of AAA batteries (or AA-size with an adapter), which were used in the original Maxxum 5000 and 7000. The lithium power source is lighter, more compact, and provides longer life plus superior low temperature response.

Series Compatibility

Since the configuration of the "i" series bodies differs substantially from the original Maxxum 5000, 7000, and 9000 cameras, the backs are not interchangeable. The Data Back DB-70, Program Back PB-70, Program Back Super 70, and Program Back Super 90 will only work on the original series' camera bodies. Minolta changed the designation of the data backs designed for the newer "i" series. The Data Back DB-3/5/7 and Program Back PB-7 are intended to work with the second-generation "i" series cameras only.

The Flash Shoe Adapter FS-1100 can be used to attach non-OEM (Original Equipment Manufacturer) and earlier Maxxum flash units or shoe-mounted accessories to the newer "i," "xi," and "si" series cameras. Adaptable accessories include the Maxxum Flash 1800AF, 2800AF, and 4000AF; Macro Flash 1200AF; Control Grip CG-1000; Wireless Remote Controller IR-1N Set; and the Data Receiver DR-1000. (The Wireless Controller IR-1N Set and Data Receiver DR-1000 cannot be used with the 3000i and 5000i cameras.)

The Flash Shoe Adapter FS-1200 permits the use of the new dual-rail Maxxum flash units with earlier Maxxum 5000, 7000, and 9000 SLR cameras. As expected, certain advanced functions of the units will not operate with the earlier technology of the original series cameras. For more information about adapters and other accessories, see the chapter *Maxxum Accessories.*

Using the Maxxum 7000i

Main Power Switch

The main power switch on the top left of the camera has three positions: "LOCK," "ON," and ")))." Both the "ON" and ")))" positions turn everything on so the camera is operable, however switching to ")))" activates the audible beeper. At this setting, the camera will beep when the shutter speed is too slow for handheld pictures in Program or Aperture Priority modes and when the self-timer is in use.

As a safeguard, the camera will beep when the switch is at either the "ON" or ")))" position in two instances. It will beep for one

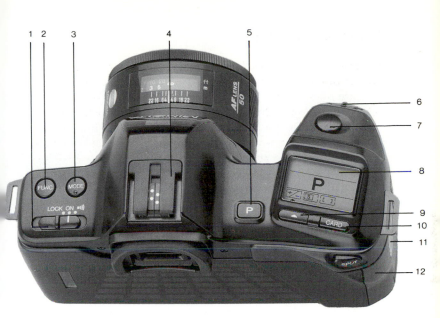

1	Main power switch	7	Shutter release button	
2	Function adjustment button	8	LCD data panel	
3	Exposure mode button	9	Function selector key	
4	Accessory shoe	10	Card on/off key	
5	Program reset button	11	Card window	
6	Up/down control	12	Card door	

second to inform you if the film is loaded incorrectly, and it will beep if the battery becomes too low for continued use.

When the camera is not in use, it should be in the "LOCK" position to prevent taking any pictures accidentally and conserve the battery.

1	Battery cover lock	4	Tripod socket
2	Battery cover	5	Film window
3	Serial number		

Installing the Battery

The 7000i uses a 6-volt 2CR5 lithium battery to power all camera functions including winding, autofocusing, and exposure control. To change the battery, first move the main power switch to the "LOCK" position. Use a coin to turn the slotted battery cover lock on the base to the "OPEN" position, remove the battery cover, then tilt the camera to let the existing battery drop out. Wipe the battery terminals with a clean, dry cloth to ensure proper contact. Clean the terminals inside the body with a pencil eraser if they are dirty, and remove any residue by blowing into the chamber. Insert the new battery according to the indications inside the compartment. Replace the cover and turn the lock to the "CLOSE" position.

Each time the main switch is moved from "LOCK" to the "ON" or ")))" positions, the camera automatically checks the battery condition. A solid black battery symbol will appear on the LCD panel for five seconds when the power level is sufficient. If the battery symbol is only partially black, the battery is getting low. If that symbol blinks, the camera can still be operated, but the battery should be changed soon. If the low-battery symbol appears alone with no

other indications on the LCD panel, power is too low for normal operation and the battery must be replaced immediately. The shutter will lock and the camera may beep as a warning.

Loading the Film

First, turn the main power switch on. Check the frame counter to determine if "0" or no number is displayed (or check the film cassette window on the back of the body to be sure no film is loaded). Now it's safe to open the back cover. Press in the center button and slide the release downward. Always load or unload film in subdued light or the shade of your body. Never allow a film cassette be exposed to direct sunlight.

Place the film cassette into the chamber on the left fitting it into the slotted pin protruding up from the bottom of the chamber. Extend the tip of the film leader past the red index mark at the base of the take-up chamber. Make sure that the sprocket holes in the lower edge of the leader engage the sprocket teeth. If the film extends too far or does not lie flat, gently push the excess film

| 1 | **Main power switch** | 3 | **Film chamber** |
| 2 | **Sprocket** | 4 | **Leader index** |

back into the cassette until it does. Never touch the shutter curtains or the pressure plate on the camera back.

Close the back, making sure it snaps and locks shut. The camera will automatically wind the film to the first frame, and the numeral "1" will appear on the LCD panel. If you are loading DX-coded film, the film speed is automatically set and will be displayed for five seconds.

If the film is not loaded correctly, the frame number will signal "0" and blink, the camera will beep for one second, and the shutter release will not operate. Repeat the loading steps being extra careful that the film is fully extended to the red index and is perfectly flat.

Setting the Film Speed
If you are using DX-coded film, the film speed is automatically set and displayed briefly in the LCD panel. If you are not using DX-coded film, you must set the correct ISO film speed manually using the ISO button inside the card door. Move the up/down control in front of the shutter release to the left to set a lower speed or to the right for a higher speed. After the correct ISO is set, press the shutter release button lightly to return to the normal operating mode. You can check the film speed at any time by pressing the ISO button.

Sometimes photographers prefer to slightly under- or overexpose their film. This is usually done with color transparency (slide) film since it is more sensitive to minor changes in the exposure to achieve deeper, richer colors, or lighter film density, respectively. This can easily be done by manually adjusting the ISO button inside the card door.

Rewinding the Film
After the last frame is exposed, the camera will automatically start rewinding the film. With a fresh battery, it will take about ten seconds to rewind a 36-exposure roll. When the film is completely rewound, the motor switches off automatically, the film cartridge symbol blinks on the LCD panel, and "0" appears on the film counter. The film leader will be wound completely into the cassette. If desired, the film leader can be left out by inserting the Customized Function Card into the card door *before* you have reached the end of the roll and the camera has automatically rewound the film.

It is also possible to rewind the film before the last exposure is made. To start the rewind, open the card door and press the rewind button.

Taking Pictures

Taking pictures couldn't be simpler. Slide the main switch to))), then press the program reset "P" button to set the camera for totally automatic operation. When the "P" button is pressed, the camera is set to program exposure mode, autofocus, single-frame film advance, no exposure compensation, and wide-area autofocus.

Hold the camera firmly, supporting the lens with your left hand cradling the barrel, right hand on the grip, and elbows tucked in against your body. Take care not to touch the lens focusing ring at the front edge. Look through the viewfinder, center the focus frame on your subject, and press the shutter release button partway down. The camera will focus, and the exposure settings determined by the meter will be displayed both in the viewfinder and the LCD panel.

A green focus signal dot at the lower left portion of the viewfinder information display will glow when the subject is in focus. If a red focus signal blinks (because the subject lacks contrast and is difficult to focus properly) you should switch to manual focus. Or, set autofocus on some other target the same distance away (a door frame or tree perhaps) and maintain pressure on the button. This locks and holds focus while you recompose the picture.

If the camera beeps continuously, the shutter speed is too slow for sharp, handheld pictures. When this warning sounds, either attach a flash unit or use a tripod. You may also switch to film with a higher ISO rating to achieve shutter speeds that are fast enough to take a picture without the aid of tripod or flash.

To take a picture, gently press the shutter release button down completely. Always use a steady, smooth motion; never jab at the release, as blurring could occur. After each picture is made, the film is automatically advanced to the next frame and the frame counter number increases by one. Your pictures should be sharp and nicely exposed.

Focus

Intelligent Autofocus System

The new, computerized AF module design found on the 7000i and 8000i cameras allows the photographer to focus on a wider range of subjects, including off-center and rapidly moving subjects. This autofocus system lets you elect to use either the wide focus area or the more specific center focus area, depending on what the situation calls for.

There are three autofocus sensors: two vertical sensors on either side of the wide focus area, and a rectangular horizontal sensor in the center of the frame. The horizontal sensor defines the center focus area and recognizes subjects with dominant vertical lines or patterns. Conversely, the two vertical-positioned sensors define the boundaries of the wide focus area and work best with subjects that are primarily horizontal in nature. When the camera is set to utilize the wide focus area, all three sensors are active. When it is set to the center focus area, only the horizontal sensor is active.

The combined sensor area produces a very wide focus area, so it is less crucial to position the subject precisely in the middle of the viewfinder field, as was necessary with the original Maxxum cameras. Slightly off-center subjects can be focused instantly.

Note: If there is more than one subject within the wide focus area of the viewfinder, the AF mechanism will focus on the one closest to the camera.

Very off-center subjects can be focused using the focus hold technique described later. This AF system combines the best of both sensing capabilities for focusing on a wider range of subject patterns as well as subjects that are off-center and ones that are in motion.

Selecting the Focus Area: To shift from wide focus area to center focus area AF, press the function selector key (the long key with an arrow, below the LCD) to move the function arrow on the LCD until it points to the focus area indicator at the bottom right of the LCD panel. Now, hold the function adjustment button ("FUNC," to the left of the prism) down. Move the up/down control in front of the shutter release button in either direction to select the center

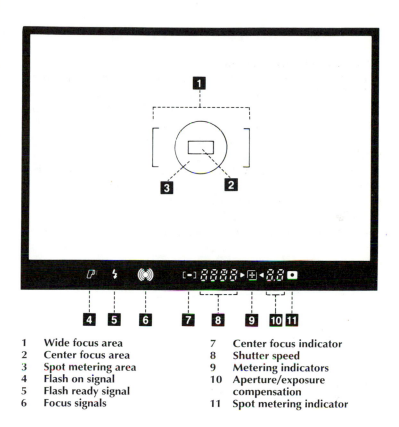

1 **Wide focus area**	7 **Center focus indicator**
2 **Center focus area**	8 **Shutter speed**
3 **Spot metering area**	9 **Metering indicators**
4 **Flash on signal**	10 **Aperture/exposure**
5 **Flash ready signal**	**compensation**
6 **Focus signals**	11 **Spot metering indicator**

focus area symbol ([■]) or the wide focus area symbol ([]) in the data panel.

These focus area settings can be used with both autofocus and manual operation. The camera automatically defaults to the wide focus area setting by pressing the program reset "P" button to the right of the prism. Pressing "P" will also set the camera instantly to Program mode, autofocus mode (with wide focus area), single-frame film advance, and +/- 0.0 exposure compensation.

AF Illuminator: The 7000i has an AF illuminator positioned permanently in the camera body near the lens axis. This will project a bright red grid pattern on the subject, giving the AF sensors a

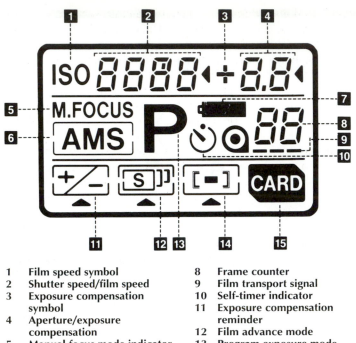

1	Film speed symbol	8	Frame counter
2	Shutter speed/film speed	9	Film transport signal
3	Exposure compensation symbol	10	Self-timer indicator
4	Aperture/exposure compensation	11	Exposure compensation reminder
5	Manual focus mode indicator	12	Film advance mode
6	Other exposure mode indicator	13	Program exposure mode
7	Battery condition	14	Focus area
		15	Card in use

reliable target in low light. This on-camera beam is aimed far more accurately than those incorporated into flash units. The illuminator has an operational range of up to 30 feet (9 m) with a 50mm lens.

Focus Hold: Photos are often more interesting when the subject is not in the center of the picture. When you want to take a photo of a non-moving subject that is very off-center, aim the camera's central focus mark on the primary subject. Press the shutter release button partway down to activate the autofocus mechanism. Maintain light pressure on the button to lock the focus while you reframe for a more dynamic composition. Now press the shutter

release all the way down to make the picture with the primary subject anywhere in the viewfinder. The focus hold also locks the exposure reading on the subject.

As long as the subject remains within the focus area as indicated by the marks in the viewfinder, focus will be continuously adjusted. As a subject comes into focus, the AF system makes additional readings to determine if it is moving. If no movement is detected, the AF lock operates as above while you recompose.

Continuous Autofocus: If, however, subject movement is detected, the camera automatically switches to continuous AF mode and begins tracking the subject as long as the shutter release button is held halfway down. The camera's computer calculates the direction and speed of any moving subject. It will continue to adjust the focus until the instant the shutter release is fully depressed to take a picture.

The computer even takes into consideration the minute fraction of time required for the reflex mirror to move up out of the way and makes another minuscule adjustment, again depending upon the calculated speed of the subject's movement. By predicting the exact position of the subject at the instant of exposure, it increases the odds of a razor sharp photo. *The shutter cannot be fully released unless the subject is in focus.*

When in continuous film advance mode, it is possible to take a series of sequential pictures by holding the shutter release button down. The camera will automatically advance the film after each exposure, then readjust the focus prior to the next exposure.

Focus Assist Indicators: The autofocus signals inside the viewfinder provide full information on the type of focusing in use. A single green LED with curves on each side, (•), indicates the focus is locked on a stationary subject. In this case, you can recompose the picture and focus will be held. If this same green dot shows progressively more curves on each side, ((•)) or (((•))), the camera is focusing on a moving subject; focus is being continually readjusted, and the shutter can be released.

However, if a series of curves appears without a green LED in the center, (), (()), or ((())), the subject is moving too fast for the AF system. In this situation, the camera will not fire, avoiding an unsharp photo. When autofocusing is not possible due to very low

contrast, low light, or the subject is too close, it is beyond the capability of the AE illuminator. A red LED dot will blink in the viewfinder. Again, the shutter release will be locked. In this rare occasion, switch the focus to manual mode, turn the lens focusing ring until the subject appears sharp in the viewfinder, and take the picture.

Manual Focus: Slide the focus mode ("AF/M") switch on the lower left side of the lens mount downward to engage the manual focus mode. "M-FOCUS" will appear in the LCD panel. (Sliding the switch up will activate the autofocus mode). Press the shutter release lightly to activate the focus signals inside the viewfinder.

Turn the lens' focusing ring until the green LED dot glows and the subject appears sharp in the viewfinder. Press the shutter release all the way down to make the picture. In manual focus mode, metering is center-weighted.

Caution: *When using manual focus, the shutter can be released at any time, even when the subject is out of focus.*

Film Advance

There are two film advance modes on the 7000i. Single-frame mode advances the film by one frame after each exposure. To take another picture, lift your finger from the shutter release button and press it again.

In Continuous mode, film is advanced continuously at up to 3 fps as long as your finger is pressing on the shutter release. Focus is automatically adjusted between exposures to keep the subject sharp. If the shutter release is pressed down all the way before the subject is in focus, the shutter will not release until the subject is in focus.

To select a film advance mode, press the function selector key (with arrow, below the data panel) until the function pointer in the data panel points to the film advance mode symbol in the bottom center of the LCD panel. Now hold down the round function adjustment ("FUNC") button to the left of the prism. Use the up/down control in front of the shutter release to select between Single-frame ("S") and Continuous (]]]) film advance modes.

Intelligent Exposure Control System

With the introduction of the Maxxum 7000i, Minolta combined an AF-integrated, multi-pattern, six-segment metering system with an expanded AF sensor. Other brands of cameras' multi-pattern metering systems relied primarily on stored data regarding various lighting situations to arrive at an exposure. But, since the AF sensors in those cameras relied only on central autofocusing, they also assumed that the central reading area would also include the primary subject.

Minolta engineers and technicians had the opportunity to incorporate breakthrough metering technology that was integrated with the autofocus system via the wider focus sensor area. Thus, they could base the exposure on the area of the scene in which the subject is actually located. As soon as the subject is in focus, the camera calculates and locks an appropriate exposure setting. By keeping your finger lightly on the shutter release, both exposure and focus remain locked and you can recompose and take the picture.

The multi-pattern metering system operates in "real-time," so even when metering moving subjects or subjects moving into variable lighting situations, the metering pattern adjusts constantly. Exposure is varied when the subject's position or distance, or the focal length of the lens changes.

Image magnification is calculated by the camera's computer using both the focal length and focus distance data supplied by the lens' ROM (Read Only Memory) integrated circuit. This data is constantly furnished during the metering calculation, resulting in automatic adjustment of the meter sensitivity pattern to match the position, shape, and magnification of the subject. These metering patterns can change from center-weighted to off-center spot metering during one exposure, depending upon where the camera's AF sensors place the subject. Even the exposure reading of the subject and background are compared to determine if the scene is evenly illuminated, backlit, or spotlit.

Spot Metering
Some unusual subjects require more selective metering than that offered by the camera's six-segment, center-weighted metering system. Typically problematic subjects are subjects that fall within

the midtone range positioned against a very dark background, or subjects with high-contrast elements. In these cases, try spot metering, which restricts the meter reading to only the small 2.3 percent circle in the middle of the viewing screen.

First aim the camera so the primary subject fills the circle—perhaps a tanned face on an extremely bright beach or ski mountain. To use spot metering, with your right thumb press and hold in the button labeled "SPOT" on the back of the camera. Now recompose and focus as needed, then press the shutter release button to take the picture.

In autoexposure modes the spot button must be kept pressed in until the shutter is released. In manual mode the spot button needs to be held down only until your exposure adjustments have been made. While the "SPOT" button is depressed, a box with a dot in the middle ([•]) is visible in the bottom right of the viewfinder to indicate that it is in use.

Hint: With a Maxxum dedicated flash attached and the camera set to either Program or Aperture Priority mode, you can use the "SPOT" button to program a slower shutter speed by metering ambient light for night shots. Just aim the center focus sensor at the area of light you want to meter and press the "SPOT" button. Keep your finger on the shutter release to lock the exposure until you have recomposed the frame and shoot the picture. This will keep the background from becoming underexposed due to a sync speed that is too fast. The flash will light the foreground and yet the shutter will be open long enough for information not lit by the flash (such as city lights) to register on film. The shutter speed will be based on the prevailing light, not the faster flash sync speed, which could result in a rather dark background.

Automatic Multi-Program Selection
Included with the exposure control system is the AMPS (Automatic Multi-Program Selection), first used in the Maxxum 7000. This has been expanded from three to an unlimited number of exposure programs for any prime or zoom lens. The programs that are automatically selected favor smaller apertures for more depth of field with short focal length lenses and faster shutter speeds with longer focal length lenses to minimize possible camera movement.

The program will attempt to select the fastest shutter speed

possible to produce sharp handheld pictures. Typically, these calculated shutter speeds will be approximately equal to the reciprocal of the focal length of the lens in use. Therefore, the camera will program a shutter speed of 1/60 second with a 50mm lens, and 1/250 second with a 200mm lens. If the shutter speed calculated is too slow for handheld exposure, the camera will beep when the main power switch is set to))). If the scene is deemed too dark or too bright for correct exposure, the metering indicators (two opposing arrows) will blink in the viewfinder. It is then advisable to use a flash or change to a faster film.

Program Mode
Program mode is designed as the main exposure mode for the 7000i. It is ideal for general photography because you just aim the camera and take your picture. All focus and exposure settings are made by the camera automatically; no manual settings are required.

To use the factory programmed settings, simply press the large program reset ("P") button. The letter "P" will then appear in the LCD panel. Instantly the camera defaults to Program exposure mode, AF with wide focus area, single-frame advance, and +/- 0.0 exposure compensation.

Even those who like to shoot primarily in another mode have occasions when they want to reset everything to fully automatic for quick snapshots that require little thought. The automatic reset feature is a very nice way to accomplish this without having to fuss with several different buttons and controls.

To change just the exposure mode from Aperture Priority, Shutter Priority, or Manual to Program, hold down the exposure mode ("MODE") button on the left of the prism while pressing the program reset ("P") button. When the camera is reset in this manner no other camera settings will be altered.

Program Shift: Sometimes you will want to select other aperture-shutter speed combinations without altering the overall exposure in Program mode. For instance, a faster, action-stopping shutter speed or a smaller aperture for more depth of field may be desirable. The built-in programmed operation can be shifted in half-stop increments.

Just slide the up/down control in front of the shutter release

1	Main power switch	5	Function selector key
2	Function adjustment button	6	Shutter release button
3	Exposure mode button	7	Up/down control
4	Program reset button	8	LCD data panel

button to the left for slower shutter speeds and smaller apertures. Sliding this same control to the right would shift the internal program towards faster shutter speeds and wider apertures. Shifted settings are held only five seconds after your finger is lifted from the shutter release button. To take several pictures using Program Shift, keep your finger resting lightly on the shutter release button.

When using zoom lenses, shift the program *after* zooming, because whenever you change the focal length, the shifted settings will also change.

Aperture Priority Mode

In Aperture Priority ("A") mode you can set the aperture (f/stop) yourself to control the degree of sharpness in the picture. The camera will automatically set the shutter speed for the correct

124

exposure. This semi-automatic mode is ideal for controlling depth of field in situations such as photographing nature, scenics, portraits, and close-ups.

To select Aperture Priority mode, hold down the exposure mode ("MODE") button to the left of the prism and slide the up/down control in either direction until "A" is displayed on the LCD panel. The pointer next to the aperture setting on the LCD panel indicates that it now can be set manually. Move the up/down control to the right to set smaller aperture numbers and to the left to set larger aperture numbers. The aperture will move in half-stop increments each time the up/down control is moved.

The f/stop numbers will change more rapidly when the up/down button is held down continuously in either direction. Any available aperture from the range indicated on the front of the AF lens on the camera can be selected.

If the shutter speed required is not available, the shutter speed will blink in the LCD. If "4000" blinks, set a smaller aperture until the blinking stops. If "15" blinks, set a larger aperture.

If the shutter speed selected by the program is too slow for hand-held exposure, the camera will beep when the main power switch is set to))).

When the lighting conditions are too bright or too dark for a correct exposure, the two triangular metering indicators inside the viewfinder will blink. In low light, use a Maxxum flash to provide adequate light for the subject, or switch to a faster film.

Shutter Priority Mode
Shutter priority ("S") mode is desirable for taking pictures of moving subjects. You may decide to select a very fast speed of 1/2000 or 1/4000 second to freeze fast action in bright light. Or you may switch to a slower speed such as 1/15 second to purposely blur the subject's movement or blur the background when the camera is panned. The camera will automatically set the aperture to provide the correct exposure and will display it at the nearest half-stop. Again, the selected shutter speed will remain in effect until you change it.

To select "S" mode, hold down the exposure mode button (labeled "MODE," to the left of the prism) and slide the up/down control in either direction until "S" is displayed on the LCD panel. The pointer next to the shutter speed setting on the LCD indicates

that it can now be set manually. Move the up/down control to the right to set faster shutter speeds and move it to the left to set slower shutter speeds. The speeds will move *in full-stop increments* each time the up/down control is moved. The speeds will change more rapidly when the up/down button is held in either direction. Any available shutter speed from 1/4000 second to 30 seconds can be selected.

Note: The aperture setting will blink in the LCD panel if the required aperture is not available. For instance if the smallest aperture available blinks, set a faster shutter speed until the blinking stops. If the largest aperture available on the lens blinks, set a slower shutter speed until it stops. When the lighting condition is too bright or too dark for a correct exposure, the two triangular metering indicators will blink inside the viewfinder. In low light, use a Maxxum flash to provide adequate light or change to faster film. Even though the "bulb" setting can be selected in the "S" mode, *this setting cannot be used.* Bulb exposures can be made only in Manual mode.

Manual Mode

Manual ("M") mode is useful when the photographer wants to have complete creative control over the exposure. In this mode, the photographer sets both the aperture and shutter speed, but still the indicators light in the viewfinder to assist in obtaining the correct exposure. It is possible to vary the exposure from that recommended by the camera based upon your own personal experience.

To select "M" mode, hold down the exposure mode button and slide the up/down control in either direction until "M" is displayed on the LCD panel. The pointers on the LCD next to both the shutter speed setting and the aperture indicate that they can now be set manually.

To set the exposure using autofocus, press the shutter release button down halfway to focus and meter your subject. Holding the button halfway down keeps the meter on. A metering indicator arrow will appear in the viewfinder between the shutter speed and aperture settings.

If the metering system considers your settings correct for accurate exposure, two arrows pointing at each other (with a blank

area between them) will be visible in the viewfinder. If the meter suggests that adjustment is needed, a small box with either a "-" or "+" will appear. Only one triangle will show, pointing in the direction the up/down control should be moved.

Note: Feel free to ignore these indicators if you are intentionally increasing or decreasing exposure for photos of a snowy landscape or a black Jaguar, for instance. If your experience indicates that such adjustment is required to render a subject accurately (truly white or black instead of gray), proceed to shoot. However, be sure to check the amount of deviation from the camera's recommended exposure. Start at the camera's recommended settings, then count the number of shutter speed or f/stop adjustments you make.

If both triangular pointers blink, the light level is beyond the metering range and correct exposure cannot be determined. The "-" or "+" symbols indicate whether the exposure will result in underexposure (-) or overexposure (+) if the displayed shutter speed-aperture combination is used.

Exposure Compensation

Sometimes you will want to adjust the "normal" metered setting to give a scene more or less exposure. As we have mentioned, this can be done easily in Manual mode.

In automatic modes, however, you'll need to use the exposure compensation function. You may decide to shoot several frames at different compensation levels to get one perfectly exposed frame. This technique, called "bracketing," is most useful with slide film, which has the least latitude for exposure error of any film type.

To use the exposure compensation feature, press the function selector key below the LCD to move the triangular pointer until it is under the small box on the left side of the LCD. Next, hold down the function adjustment ("FUNC") button to the left of the prism and simultaneously move the up/down control. A move to the right sets "+" values to overexpose for a brighter rendition. A move to the left sets "-" values to underexpose and create a darker effect. The entire compensation range is from +4 to -4 stops in half-stop increments.

Whenever an exposure adjustment is set, "+" or "-" will appear in the left-most box on the data panel and at the base of the

viewfinder. The adjusted value can be checked by pressing the function adjustment key when the triangular pointer is below the exposure compensation reminder box on the LCD panel.

Note: Remember to reset the exposure compensation value back to "+/- 0.0" after shooting pictures requiring this function. Otherwise, the remainder of your pictures may not be exposed correctly.

Other Controls

Self-Timer
The 7000i has a handy, built-in, electronic self-timer. Once activated, it will delay the shutter release for ten seconds to give the photographer time to get into the picture. This feature is also useful for tripping the shutter without creating vibration during long exposures while the camera is mounted on a tripod.

To use the self-timer, open the card door on the right side. Press the self-timer button on the top of the door. A round, clock-like symbol will appear on the LCD panel. Focus the lens, then attach the eyepiece cap stored on the neck strap over the eyepiece cup so that light from behind the camera will not influence the metering. Now press the shutter release button down all the way to start the self-timer. The camera will beep if the main power switch is set to))). A red light on the front of the camera will blink twice a second for ten seconds until the shutter releases.

The self-timer will switch off automatically after the exposure is made, and each step must be repeated to take a second picture. If the countdown has not yet begun, the timer can be cancelled by pressing the self-timer button a second time. If you have started the self-timer and want to stop it before the shutter releases, move the main power switch to "LOCK" and then back to "ON" for normal operation.

The "Bulb" Setting
There are situations when even the longest possible timed shutter speed will not be long enough. Fortunately, the Maxxum 7000i offers a "bulb" setting, which allows the photographer to hold the shutter open for as long as necessary. The camera must be set to Manual mode and no exposure guidance is provided by the meter.

Using the "Bulb" Setting: First, mount the camera on a tripod. Set the camera to "M" mode, then hold the up/down control to the left until "bulb" appears on the LCD panel and at the base of the viewfinder. Set the aperture by holding in the aperture setting button and sliding the up/down control to the right or left. If it is too dark for autofocusing, switch the lens to manual focus mode. Focus by turning the lens' focusing ring until the subject is sharp in the viewfinder. If the subject is too dark or at infinity, set the focus using the lens' distance scale.

To take the picture, hold the shutter release down for the desired amount of time. No metering guidance is provided, so you'll need to base the exposure time on a handheld meter reading, experience, guesswork, or hints found in photo books and magazines. It is recommended that you use the accessory Remote Cord RC-1000S (short) or RC-1000L (long) to minimize the possibility of blurring in your photos (see below).

System Accessories

Remote Cord: Even with the camera mounted on a sturdy tripod, there is always the possibility that it could move when the shutter release button is pressed. The Minolta accessory electric Remote Cord RC-1000S, (20 inches, 0.5 m) or RC-1000L (16.5 feet, 5 m) plugs into a three-pin socket below the 7000i's card door, giving you a motion-free shutter release. An additional feature is that the remote cord control can be locked in the "ON" position when you are shooting very long exposures (e.g., fireworks or lightning). The Maxxum remote cords are described further in the chapter *Maxxum Accessories.*

Using Flash with the 7000i: The 7000i incorporates an advanced flash control system for correct flash exposures anytime in daylight, low light, or total darkness. In all modes the camera's TTL flash metering system controls the flash output of dedicated flash units to assure proper flash exposure.

When using a Maxxum dedicated flash such as the Maxxum 2000i, 3200i, or 5200i, two flash symbols appear inside the viewfinder. The "flash on" symbol (a silhouette of a flash unit) appears whenever the flash is switched on; a jagged "flash ready" symbol will appear and blink when it is fully charged.

After taking a flash picture, the same jagged flash ready symbol will blink rapidly to signal that the exposure was sufficient. The 7000i will fire the flash whenever the light level is very low or in strong backlit, daylight situations if fill flash is required. A special fill-flash program helps lighten shadows without washing out highlight details when the flash is used in daylight situations.

Maxxum Flash 3200i: The 3200i flash has been designed with a lower profile and slopes slightly forward, making it look like it is an integral part of the camera; it does not make the body top-heavy. It can also be left on the camera comfortably during any shooting situation. The flash features an internal zoom mechanism that automatically adjusts its flash coverage for a 28mm to 85mm lens. A low power setting is useful when using the flash on close subjects or when in motor drive operation at 3 frames per second. For more information about various Maxxum flash units, see the chapter *Maxxum Accessories.*

Creative Expansion Cards: There are 25 different Creative Expansion Cards that can be used in the special card door. First introduced with the 7000i, these cards can assist photographers in customizing the camera to take the type of pictures they particularly enjoy photographing. These small cards are described further in the chapter *Maxxum Accessories.*

Minolta Maxxum 7000i Specifications

Type: 35mm SLR with intelligent control of autofocus, autoexposure, and auto film transport systems.

Lens Mount: Minolta A-type bayonet, accepts all Minolta AF lenses.

Autofocusing System: TTL phase-detection type with three charge-coupled device (CCD) sensors; two vertical, one horizontal.

AF Sensitivity Range: EV 0 to 18 at ISO 100; selectable wide or center focus area; built-in AF illuminator triggered automatically in low light or low contrast, range 3.3 to 30 feet (1 to 9 m).

Manual Focusing: Visually on acute-matte focusing screen and/or by referring to focus indicators in viewfinder.

Metering: TTL multi-pattern metering coupled to autofocus system; center-weighted average in manual; six-segment SPC (silicon photocell) for ambient light; second SPC at bottom of mirror box for TTL flash metering.

Autoexposure Range: EV 0 to 20 with ISO 100 film, 50mm f/1.4 lens.

Exposure Modes: Program AE—automatic multi-program sets shutter speed and aperture based on focal length of lens in use; Shutter Priority AE—any speed from 1/4000 second to 30 seconds selectable in full stops, aperture set automatically by AE program; Aperture Priority AE—any available aperture selectable in half-stops, shutter speed set automatically by AE program steplessly from 1/4000 second to 30 seconds; Manual—any shutter speed and aperture combination possible, correct exposure and under- and overexposure indicated in viewfinder, "bulb" setting for long exposure.

Exposure Controls: Compensation factor can be set to +/- 4 EV in half-stops.

TTL Flash Metering: Operates in all modes with dedicated flash, shutter automatically set to X sync when flash-on signal appears in viewfinder. Pressing spot metering button in "P" or "A" modes sets slower shutter speed (up to 30 seconds) to balance flash with ambient lighting. Program AE—automatically sets aperture and shutter speed between 1/125 and 1/20 second according to focal length of lens in use, flash fires automatically when required; Shutter Priority AE—same as Program AE; Aperture Priority AE—shutter speed automatically set to 1/125 second, any available aperture usable.

Shutter: Electronic vertical focal plane type. Stepless range of 1/4000 second to 30 seconds in "P" and "A" modes; 1/4000 second to 30 seconds in full-stop settings in "S" and "M" modes, plus "bulb" in "M" mode.

Controls: Buttons set exposure mode, film advance mode, exposure compensation, wide or center focus area, and film speed. Up/down control to change shutter speed and aperture settings and to control program shift; spot metering button; program reset button.

Exposure Controls: Exposure compensation range of +/- 4 in half-stop increments, AE lock coupled to focus lock, spot metering usable in all exposure modes, program shift in half-stop increments for temporary selection of other programmed aperture-shutter speed settings.

Film Speed Range and Settings: ISO 25 to 6400 in ambient light; ISO 25 to 1000 for TTL flash metering, both in third-step increments; automatic film speed setting for DX-coded films from ISO 25 to 5000, can also be changed manually.

Film Transport: Built-in motor drive; single-frame or continuous advance at up to 3 fps. Automatic or manual rewind start. Advancing frame counter in data panel. Shutter locks and audible and visual signals warn that film is loaded incorrectly.

Viewfinder: Eye-level fixed pentaprism; 92 percent vertical and 94 percent horizontal field of view; magnification 0.84x with 50mm lens at infinity. Shows wide and center focus areas and spot metering area.

Data Display: LCD panel shows exposure mode, shutter speed, aperture, manual focus mode, film speed, frame number, self-timer operation, "bulb" operation, battery condition, exposure adjustment, film advance mode, focus area selected, card function in use. Automatically illuminates in low light.

Viewfinder Display: LCD illuminated in low light. Shows shutter speed, aperture, exposure adjustment, film speed, whether light level is within metering range, over- and underexposure warning; focus status indicated by a combination of LEDs and backlit LCD.

Power: One 6v 2CR5 lithium battery; automatic battery condition checking, offers four-stage condition indicator on data panel.

Shutter locks when battery is exhausted. Main power switch has "LOCK," "ON," and ")))" (audible signal) positions.

Self-Timer: Electronic with 10-second delay; cancelable.

Other Components: Cushioned eyepiece frame, eyepiece cap, film window, remote-control socket, carrying strap.

Dimensions: 6 x 3-11/16 x 2-11/16 in. (153 x 93 x 69 mm).

Weight: 20.5 oz. (590 g) without lens and battery.

Minolta Maxxum (Dynax) 8000i

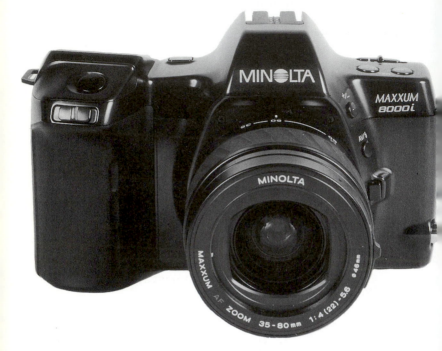

The Minolta Maxxum 8000i was introduced early in 1990 as the top-of-the-line model in the second generation of Maxxum cameras, the "i" series. If not already familiar with the Maxxum 7000i, introduced only two years earlier, you will find the location of the operating controls on the 8000i quite logical and readily accessible. Except for the stylish two-tone gray finish on the body, the 8000i looks nearly identical to the 7000i. But upon closer investigation, you will begin to notice small but significant differences and improvements. This camera is geared more to the advanced photographer and offers instant override features that give you considerably more control over the camera's many automatic functions, such as Program mode.

Since the 8000i is so similar to its sister model, the 7000i, this

chapter will concentrate only on its new features and their opera-
tion. To learn about the basic operation of the 8000i, please refer
to the instructions for the 7000i, found in the previous chapter.

New Features

PC Sync Terminal

Probably the most significant addition to this camera from a seri-
ous photographer's point of view is the PC flash terminal that is
available in addition to the dual-rail hot shoe on the prism. This
terminal will accept a PC sync cord from a studio flash or any
other type of high-powered flash unit operated by a PC contact,
allowing you to connect a broad range of professional flash units
as well as flash units made by other manufacturers.

Note: As with most cameras, flash units connected through the
PC terminal will not function with the camera's TTL flash system.
Consequently, you must either calculate your exposure manually
or use an accessory flash meter. You will need to use Manual mode
and set the shutter speed at 1/125 second or slower. However, if
you use the Customized Function Card, the maximum flash sync
speed available will be 1/180 second.

Caution: Never connect a flash unit through the camera's PC ter-
minal while a Maxxum flash unit is attached to the camera's hot
shoe, as this could damage the Maxxum flash.

Aperture Value/Flash Button

The aperture setting button to the left of the lens mount serves two
purposes. Not only does it set the aperture in half-stop intervals
when the camera is in Aperture Priority or Manual modes, but it
also forces the flash to fire when daylight fill flash is required.
Pushing this button overrides the standby condition of any
Maxxum "i" series flash unit and force-fires the fill flash even
though the camera's metering system may not sense that it is nec-
essary. Unlike the Maxxum 7000i, whose electronics may not fire
the fill flash even though the photographer would like to, the more
advanced 8000i gives you control to override the camera's hot-
shoe flash.

Focus-Hold Button

Another new feature not found on previous Maxxum camera bodies is a focus-hold button. This is located on the back of the camera, just to the left of the LCD panel, where it can be easily pressed by your right thumb. A focus-hold button was previously offered on several Maxxum lenses, such as the 70–210mm, 100–300mm zooms, 500mm reflex, and the long, apochromatic telephotos, but not on Maxxum camera bodies.

Although you can still use the shutter release button to lock focus (by pressing it down halfway) for one exposure, pressing the focus-hold button in tandem with the shutter release will disengage the autofocus system and hold the locked setting for as long as the focus-hold button is depressed. This is particularly handy when shooting a series of exposures of an off-center subject in continuous film advance. The dedicated focus-hold button allows you to lock focus on the subject and maintain it even if the subject drifts beyond the central focus frame or if another subject enters the focus area closer to the camera than the original subject. Both of these situations are out of the control of the shutter release's focus-hold capabilities.

Installing the Custom Function Creative Expansion Card expands this button's capabilities, allowing you to instantly select continuous AF or to switch focus from the wide to the center focus area.

Auto DX Memory

An exclusive feature of the 8000i is an Auto DX memory. Whenever a DX film speed setting is changed manually, the camera's computer will remember the altered film speed when subsequent film cassettes with the identical DX code are loaded. This is a real time-saver when you are working on a fast-paced job and you purposely want to use an altered film speed on several rolls of the same film, a situation pros frequently encounter. If you insert a roll with an identical DX code and you want to shoot it at its actual film speed, you must set the DX code manually to override the altered code. When a roll of film with a different DX-coded ISO rating is inserted, the memory is automatically erased and the actual film speed for that roll will be set.

Ultra-Fast Shutter Speed

This camera also includes an extremely fast, action-stopping 1/8000 second shutter speed. When photographing extremely fast-paced action (such as an auto race), you may want to use this shutter speed. Don't forget, this will only be possible with lenses having a very wide aperture (such as f/2 or f/2.8), with very fast film (ISO 400 or greater), and under very bright conditions. Few subjects will require such a fast shutter speed, but it is available on the 8000i in case you ever need it.

Eye-Relief Viewfinder

Finally, the 8000i has an "eye-relief" viewfinder that allows the photographer wearing glasses or goggles to view the entire screen and data displays.

Improved Features

Exposure Compensation: The exposure compensation feature was simplified on the 8000i by placing the button on the front of the camera, left of the pentaprism. A raised dot on the button makes it easy to distinguish by touch from the Aperture Value ("AV")/flash button just below it. Exposure compensation can be made quickly in half-stop increments (within a range of +/- 4 stops) while looking through the viewfinder—far simpler than the method required for the 7000i. The viewfinder displays plus or minus indicators as a reminder that exposure compensation is still in effect.

Canceling exposure compensation is equally simple. Just press the program reset button ("P") or reverse the setting procedure.

The exposure compensation button also offers you an additional way to adjust the lens opening in half-stop increments when in Manual mode (or you can use the aperture setting button).

Spot Metering: Spot metering is another useful feature offered on both the 7000i and 8000i. When a relatively small, but important, subject is surrounded by bright or dark expanses, use this function to obtain a more accurate exposure. Press the "SPOT" button on the back of the camera under your right thumb; this immediately shifts all metering to the narrow area defined by the central circle on the viewing screen.

1	Exposure mode button
2	Main power switch
3	Function adjustment button
4	Exposure compensation button
5	Aperture value/flash button
6	Lens release
7	Back cover release
8	Focus mode switch
9	PC terminal

A further enhancement of this spot capability is obtained when the new Multi Spot Memory Card is inserted. This accessory allows you to make up to eight spot readings for one exposure. The exposure will be made based on the average of those readings.

Multiple Exposure Control: Another handy feature of the 8000i is its capacity to make multiple exposures. It offers the photographer two different methods. The simpler method, operable in either single-frame or continuous film advance, is accomplished by depressing both the round function adjustment ("FUNC") button and the exposure mode ("MODE") button on the top left of the camera while simultaneously sliding the setting control switch in either direction until the LCD panel displays "ME" (Multiple Exposure) (it will *not* appear in the viewfinder). If you change your mind and need to cancel this function, simply repeat the procedure until "ME" disappears from the LED display.

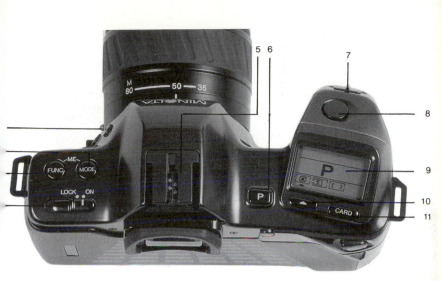

1	Main power switch	6	Program reset button
2	Function adjustment button	7	Setting control
3	Exposure mode button	8	Shutter release button
4	Exposure compensation button	9	LCD data panel
5	Accessory shoe	10	Function selector key
		11	Card on/off key

Single-frame advance mode allows only two exposures to be made on one frame of film. The exposures are adjusted by the camera's computer to produce a properly exposed double image. All you have to be concerned about is positioning the two over-laid images properly within the frame. You can expose any two entirely different subjects in different lighting conditions and with different focal length lenses, both on the same frame of film. This can be done with conventional lighting, with TTL flash, or any combination thereof. After making two exposures, the multiple exposure function is canceled automatically, and the film advances to the next frame.

In continuous film advance mode, it is possible to make as many images on the same frame of film as desired, as long as the shutter release button is held down. However, the camera will not com-pensate for exposure values as it does in single-frame advance

mode. In autoexposure mode, each exposure will be made as if it were a single frame, and you could end up with a severely over-exposed photograph. You must compensate exposure either manually or use the exposure compensation control. Consult the following chart for suggested multiple exposure compensation values:

No. of Exp.	2	3	4	5	6	7	8	9
Exp. Comp.	-1	$-1^{1}/_{2}$	-2	$-2^{1}/_{3}$	$-2^{1}/_{2}$	$-2^{2}/_{3}$	-3	$-3^{1}/$

Another rule of thumb for making multiple exposures of overlapping subjects is to multiply the ISO film speed by the number of exposures you wish to make. Then, set the film speed for that figure and use the autoexposure readings to set your exposures. This will underexpose each image proportionally. If, however, you are shooting non-overlapping subjects against black backgrounds, exposure compensation is probably unnecessary, and normal exposure settings can be used for each.

Yet another method of making more complex multiple exposures is by inserting an exclusive Multiple Exposure Creative Expansion software card into the card slot. This card allows you to make up to nine exposures on a single frame of film. There are three types of multiple exposure possible with the card: normal ("ME-N"), fade-in ("ME-1"), and fade-out ("ME-0"). In fade-in mode, the last exposure in the sequence receives the normal exposure; the preceding exposures are each underexposed progressively according to the exposure compensation value you have set. In fade-out mode, the first exposure receives the normal exposure, and the subsequent exposures are progressively underexposed according to the exposure compensation value set.

The fact that the multiple exposure capability is easily available on this camera is a plus, while having several methods of producing them is a definite advantage for experienced photographers who utilize this creative technique. For further information about Creative Expansion Cards, please consult Minolta's detailed instruction books.

Autofocus Control: The Maxxum 8000i's predictive, intelligent autofocus mechanism is the same as the 7000i's, with its array of three CCD (Charge-Coupled Device) sensors—two positioned vertically at each end of the wide focus area, one placed horizontally

in the center. This provides a focus detection area purported to be up to 12 times larger than that of other AF cameras made at the time.

The autofocus operates over a wide range of light levels from EV 0 to EV 18. When light levels are too low for conventional auto-focusing, a built-in AF illuminator near the shutter release automatically projects a pattern of red light, which provides the contrast the AF system requires. The AF illuminator can enable accurate autofocusing in near-dark situations at a range of 3.3 to 30 feet (1 to 9m) with a 50mm f/1.4 lens.

Exposure Modes: Four exposure modes are available of which three are automatic: totally automatic Program ("P"); Aperture Priority ("A"); and Shutter Priority ("S"). There is also a completely manual mode, "M," which also has indicators in the viewfinder to inform you if the exposure selected does not confirm to what the camera's internal meter recommends. Pressing the "MODE" button along with sliding the setting control in either direction will keep changing the mode as indicated on the LCD panel.

Metering: The 8000i offers three types of internal metering: multi-pattern, center-weighted average, and spot. Any of these can be selected by pressing the function selector key until the indicator points to the metering mode symbol on the LCD panel (the left-most symbol on the bottom). Press the function adjustment button ("FUNC") and simultaneously slide the setting control in either direction until the appropriate metering mode symbol appears on the LCD panel. The multi-pattern symbol is a box with a spot in the center, the center-weighted average symbol is an empty box, and the spot metering symbol is simply a spot.

The camera's standard metering system is multi-pattern. This system divides the image area into six segments. Separate readings are taken from each segment. The camera's autofocus system alerts the meter as to where the subject falls within the image area, and that information is integrated into the total exposure reading.

Center-weighted average metering measures the light in the entire image area without integrating information from the auto-focus system. However, more emphasis is placed on the reading from the central image area, regardless of whether the subject is located there or not.

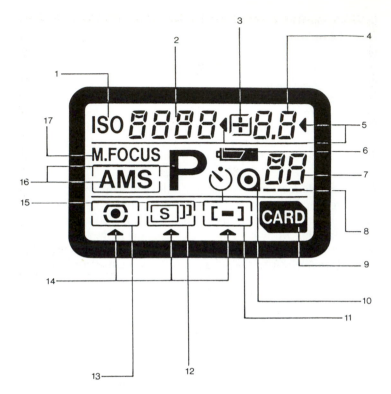

Maxxum 8000i LCD Panel

1	Film speed symbol	8	Film transport signal
2	Shutter speed/film speed	9	Card in use
3	Exposure compensation symbol	10	Film cartridge symbol
		11	Focus area
4	Aperture/exposure compensation	12	Film advance mode
		13	Metering mode
5	Selectable setting pointers	14	Function pointers
6	Battery condition	15	Self-timer indicator
7	Frame counter/multiple exposure/card setting	16	Exposure mode indicator
		17	Manual focus mode indicator

Spot metering reads only the light in the small circular area in the center of the viewfinder, only 2.3 percent of the total image area. Spot metering is activated when the "SPOT" button on the

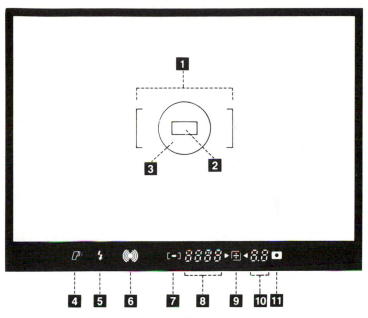

Maxxum 8000i Viewfinder Display

1	Wide focus area	7	Center focus indicator
2	Center focus area	8	Shutter speed
3	Spot metering area	9	Metering indicators
4	Flash on signal	10	Aperture/exposure
5	Flash ready signal		compensation
6	Focus signals	11	Spot metering indicator

back of the camera is held in. When the "SPOT" button is released, the metering mode previously in use is reinstated.

Control over Automation: The easily controlled and versatile Maxxum 8000i is a logical second or third camera for anyone already using its sister, the 7000i, and Maxxum AF lenses. With the cameras' operating controls in the same general location, there is no need to relearn their location or purpose, so switching back and forth between the two is easy. The 8000i is sophisticated enough to allow you to determine exactly how it is to function. By pressing the right buttons, you gain full control over an otherwise totally automatic, pre-programmed camera.

Minolta Maxxum 8000i Specifications

Type: 35mm SLR with intelligent control of autofocus, autoexposure, and auto film transport systems.

Lens Mount: Minolta A-type bayonet; accepts all Maxxum AF lenses.

Autofocusing System: TTL phase-detection type with wide charge-coupled device (CCD) sensor.

AF Sensitivity Range: EV 0 to 18 at ISO 100; predictive focus control; built-in AF illuminator automatically activated in low light; range 3.3 to 30 feet (1 to 9 m).

Manual Focusing: Visually on acute-matte focusing screen and/or by referring to focus indicators in viewfinder.

Metering: TTL type, three selectable modes: multi-pattern with six-segment cell, center-weighted average, and spot; six-segment silicon photocell (SPC) on pentaprism for ambient light; second SPC at bottom of mirror box for TTL flash metering.

Autoexposure Range: EV 0 to 20 with ISO 100 film, 50mm f/1.4 lens.

Exposure Modes: Program AE—automatic multi-program sets shutter speed and aperture based on focal length of lens in use; Shutter Priority AE—any speed from 1/8000 second to 30 seconds, selectable in full stops, aperture set automatically by AE program; Aperture Priority AE—any available aperture selectable in half-stops, shutter speed set automatically by AE program steplessly from 1/8000 second to 30 seconds; Manual—any shutter speed and aperture combination possible, correct exposure and under- and overexposure indicated in viewfinder, "bulb" setting for long exposure.

TTL Flash Metering: Operates in all exposure modes with dedicated flash; shutter X-sync speed set automatically when flash on signal appears in viewfinder. Pressing spot metering button in "P"

or "A" modes sets slower shutter speed (up to 30 seconds) for increased background exposure. Program AE—automatic setting of aperture and shutter speed between 1/200 and 1/20 second according to focal length of lens, flash fires automatically when required; Shutter Priority AE—same as Program AE; Aperture Priority AE—shutter speed automatically set to X sync of 1/200 second, any available aperture usable. Force-flash override.

Shutter: Electronically controlled vertical traverse focal-plane type; stepless range of 1/8000 second to 30 seconds with nearest half-stop setting displayed in "P" and "A" modes, range of 1/8000 second to 30 seconds in full-stop settings in "S" and "M" modes, plus "bulb" in "M" mode.

Controls: Buttons for manual start of film rewind, self-timer, focus hold, spot metering; focus mode switch; setting control for program shift, aperture ("A" mode), and shutter speed ("S" and "M" modes); setting control for manual film speed settings, metering pattern, drive mode, focus area, exposure mode, exposure compensation, aperture (in manual exposure mode), and multiple exposure, when combined with second control; program reset button sets camera to default to Program mode, single-frame advance, autofocusing with wide focus area, and cancels exposure compensation, self-timer, and multiple exposure settings.

Exposure Controls: Exposure compensation range of +/- 4 stops set in half-stop increments; program shift in half-stops for temporary selection of other programmed aperture-shutter speed combinations; multiple exposure function.

Shutter Release Button: Pressing button partway down activates autofocus and metering systems; pressing button all the way down releases shutter; in AF mode, shutter can be released only when subject is in focus.

Film Speed Range and Setting: Automatic setting for DX-coded ISO 25 to 5000 film; for films without DX coding, previous film speed setting is retained; manual setting in third-step increments from ISO 25 to 6400.

Film Transport: Automatic with built-in motor drive; auto threading, auto advance to first frame; single-frame advance or continuous advance at up to 3 fps. Automatic rewind and manual start of motorized rewind. Advancing frame counter in data panel. Shutter locks and data panel displays when film is loaded incorrectly.

Viewfinder: Eye-level fixed pentaprism shows 92 percent of vertical and 94 percent of horizontal field of view; magnification 0.75x with 50mm lens at infinity; standard acute-matte screen; user changeable. Shows wide and center focus areas and spot metering area.

Data Display: LCD data panel shows film speed, shutter speed, card name (when in use), card function in use, exposure compensation, aperture, exposure mode, manual focus, battery condition, self-timer, frame number, film transport, metering pattern, drive mode, focus area, multiple exposure. Automatically illuminates in low light.

Viewfinder Display: LED focus and flash-on indicators and flash ready signal; illuminated LCD readout for focus area, shutter speed, film speed (when set), card name (when activated), over- and underexposure (in manual exposure mode), aperture, and meter pattern.

Power: One 6v 2CR5 lithium battery; automatic battery check when camera is turned on, four-stage battery condition indicator on data panel. Main power switch has "LOCK" and "ON" positions.

Self-Timer: Electronic with 10-second delay; cancelable.

Other Components: Cushioned eyepiece frame, eyepiece cap, film window, remote-control socket, carrying strap.

Dimensions: 6 x 3-11/16 x 2-11/16 in. (153 x 93 x 69 mm).

Weight: 21-3/16 oz. (600 g) without lens and battery.

Lenses

General Review

Since the cameras described in this book are no longer part of the Minolta SLR product line-up, brand-new lenses and accessories could be difficult to locate. But dozens of used accessories made by Minolta and other manufacturers will fit these cameras and are available at retail photo stores offering used equipment. In addition to the Minolta Rokkor and Rokkor-X lenses in MC and MD mounts, there are many other brands of lenses made in Minolta mounts. MD-mount lenses for the earlier Minolta SLRs were made by independent accessory lens firms with brand names such as Kiron, Pro, Quantaray, Rokunar, Sigma, Soligor, Tamron, Vivitar, and others. Lenses from these firms couple and work properly with the non-AF Minolta SLR cameras. If you are having trouble

Minolta offers a large selection of autofocus lenses for its Maxxum cameras.

finding the used Minolta Rokkor lens you desire, don't forget to look for other brand names as well.

Lenses other than Minolta AF mount lenses that are compatible with the Maxxum series of cameras are available from many other firms as well. More common brand names that are consistently good performers are Sigma, Tamron, and Vivitar, but there are also many others. When purchasing lenses new or used, we recommend that you follow the advice of your photo dealer as to lens quality and suitability for your camera.

How many different lenses you choose to own depends upon the size of your gadget bag and the depth of your pocket. Photography can be as expensive or as reasonable as you choose if you are selective and don't succumb to every new lens or gadget offered. Learn to maximize the capabilities of the lens(es) you own before purchasing another.

Normal Lenses
The technical definition of a "normal" lens is one that has a focal length approximately equal to the diagonal measure of the film frame in use. For a 35mm camera loaded with conventional film whose frame measures 24 x 36 mm, "normal" would be a 44mm lens. A practical description of a "normal" lens would be one that closely approximates the view perceived by the human eye.

Most camera makers have designated 50mm as the focal length for a "normal" lens with 35mm film. Because it is inexpensive and versatile, the 50mm lens was the lens most frequently sold with the camera. However today there is a distinct trend to use a zoom lens instead of a single focal length lens, primarily because of the convenience of having a multitude of useful focal lengths combined into a single lens.

A 50mm focal length is also common for macro lenses. Although they are usually purchased specifically for close-up work, they can be used for general photography with subjects at any distance. They do, however, command a premium price because of their built-in close-focus capability.

For general photography, you can't beat the normal 50mm lens. It is excellent for shooting nearby subjects, like when a toddler is taking some of his first steps. ⇨

Light from the off-camera dedicated flash was softened with a light diffuser. Since metering is TTL, the fact that the light was less intense than normal did not confuse the camera's metering capability. The Maxxum AF 100mm f/2.8 Macro lens produced this razor-sharp image.

Macro Lenses

The versatility of being able to focus from infinity to a 1:1 ratio, plus the exceptional capability of properly reproducing very flat, small, two-dimensional objects in razor-sharp detail, are the hallmarks of macro lenses.

These lenses will render a flat, two-dimensional object (such as a stamp or engraving) sharply detailed and without distortion across the entire field. By contrast, if a conventional 50mm or 100mm lens (which focuses down only to about 18 inches [45.7 cm] unaided) were used with either a close-up filter or extension tube to permit it to focus down to 1:1, it would not produce as sharp detail across a similar two-dimensional subject. Conventional lenses are designed for lens speed and versatility in photographing three-dimensional objects, not for maximum sharpness and flatness of field in the macro range.

When using your macro lens to photograph at high magnification ratios, a smaller lens aperture and correspondingly longer shutter speed are typically required to maximize depth of field. Therefore, close-up work usually requires the camera to be on a tripod or other steady support to prevent blurring.

Wide-Angle Lenses

As the name implies, a wide-angle lens has a large angle of view and can include a broad expanse of a scene in a photograph. They are typically used to encompass sweeping landscapes and large groups of people or to make cramped interiors appear positively spacious. For 35mm cameras, "wide angle" describes lenses with a focal length of 35mm or less. The term ultra-wide angle is often used for 18mm, 20mm, or 24mm lenses. There are even shorter focal length lenses available, known as fisheye lenses, that take in an extreme angle of view and distort an image considerably.

A wide-angle lens, because of its very short focal length, will produce more depth of field for any subject at a given distance than other lenses set at an equal f/number. When stopped down to smaller apertures (such as f/16), wide-angle lenses produce extreme depth of field: practically everything in the foreground, middle ground, and background will be acceptably sharp.

The wing of this military in-air refueling aircraft appears to be unusually large due to the distortion caused by shooting near the tip of the wing with an ultra-wide angle 20mm lens.

Telephoto Lenses

Telephoto lenses are used to produce larger images of distant, otherwise inaccessible subjects. They are excellent for shooting landscapes, portraits, sports, and wildlife to isolate appealing details from competing elements in a complex scene.

Telephotos are generally thought of as any lens with a focal length of 85mm or longer. An 85mm to 135mm short telephoto is ideal for portraiture—a pleasing perspective is produced in head-and-shoulders shots without crowding the subject. A telephoto with a focal length of 135mm to 300mm is considered a moderate telephoto, while any lens with a longer focal length is referred to as a long telephoto or super telephoto lens. Prime long telephoto lenses usually have a rather slow maximum aperture, which tends to make them rather difficult to use in low light or with fast, action-stopping shutter speeds.

Telephotos allow you to get in closer to compose an interesting photo of a skittish subject. The depth of field is shallow and the distance between objects appears compressed, which emphasizes the main subject.
Photo: Bob Shell.

Due to the length, weight, and bulk of a telephoto lens, the camera is more likely to move or shake when a picture is taken, resulting in a blurred, unsharp image. The general rule of thumb for taking a hand-held photograph with a telephoto is to use a shutter speed at least equivalent to the reciprocal of the focal length of the lens. For example, with a 200mm lens use a shutter speed of 1/250 second or faster; with a 500mm use 1/500 second or faster.

Telephoto lenses tend to isolate the subject from its surroundings, helping emphasize specific detail. A longer focal length enhances this tendency by producing a relatively shallow depth of field. Blurring the foreground and background in various degrees prevents them from becoming distracting to the main subject. This trait is usually appreciated when photographing sporting events, for instance, where the background can be cluttered and busy.

Another trait of longer telephoto lenses is that they compress perspective, making objects appear closer together than they actually are. This can be taken advantage of to relate objects in a photograph—stacking near and distant hills, or pulling a distant landmark closer to a posing family member, for instance.

These Bigelow Chollas were captured at sunrise with an 85mm telephoto lens. Photo: B. "Moose" Peterson/WRP.

Zooms are ideal for varying composition without changing the camera's position. This is especially useful with subjects that might be wary of an approaching photographer. Photo: B. "Moose" Peterson/WRP.

Zoom Lenses

Probably the most popular lens type today and the one lens most individuals choose as their first optic for any new camera is a zoom lens. One zoom lens provides the ultimate in convenience, since a number of different focal lengths are combined into one relatively compact barrel, making it both lightweight and economical in the long run. With these lenses, you can vary the focal length while standing in one position to crop to the exact composition desired without having to change lenses.

The quality of the optics in zooms has improved dramatically so the resolution and contrast of the images produced by them are now almost equivalent to those produced with prime (single focal length) lenses of similar focal length. It is not likely that you will see any difference in an 8 x 12-inch print or projected slide. However, in an 11 x 14-inch or larger print, the image taken with a prime lens may appear to be sharper at the edges than the one taken with a zoom, especially if both are made at the lens' maximum aperture.

Another disadvantage of zoom lenses is that they tend to be slower (have a smaller maximum aperture) than prime lenses of the same focal length. That is, instead of an 85mm f/2.8 prime lens, a 35–105mm zoom probably offers an f/3.5–4.5 aperture. At the 85mm focal length, the zoom will have a maximum aperture of around f/4, a loss of one stop of light-gathering ability. This loss of one stop is seldom a problem for anyone doing general photography, but it could be a hindrance for specific photo applications such as surveillance work. Those who want to shoot without flash will need to use faster films, which are not quite as sharp as their low ISO-rated counterparts. Also, focusing at a smaller aperture is more difficult in low light, as the viewfinder image is not as bright.

When traveling you'll want a variety of focal lengths but need to keep the bulk and weight down, so a wide to moderate telephoto zoom lens is the answer. Capture detail with the telephoto setting (above), and use the wide-angle setting to take in a broader scene (right).

The more noticeable trait of practically all zoom lenses is that they produce some barrel distortion at short focal lengths—parallel lines bowing outward at the edges of the frame. At telephoto lengths, some pincushion distortion is common—parallel lines bowing slightly inward. The highly corrected apochromatic lenses seldom have much, if any, of this distortion, but the more moderately priced zoom lenses do exhibit this trait. With conventional three-dimensional subjects like scenics or people, this type of distortion is hardly noticeable.

When choosing a zoom lens, there are always "trade-offs." We advise you to look for one that encompasses the focal length range that will be suitable for as many of the general types of subjects you anticipate photographing. However, the wider the range of focal lengths covered, the larger and heavier the lens will be. Consider buying at least two lenses to cover the gamut from wide angle to telephoto. The maximum lens speed is another consideration, but remember, the faster the lens, the more costly it will be. If you seldom do much photography in existing light without flash, it might not be worth it to spend the extra money for a fast lens.

Variable-Aperture Zoom Lenses: Many zoom lenses have variable apertures. (There are a few exceptions, such as the Maxxum AF 80–200mm f/2.8 Apo.) This aperture variation is incorporated into the lens designation and imprinted on the front or the barrel of the lens. As the lens is zoomed from its shortest to its longest focal length, the actual light transmitted through the lens (called the T-stop) decreases. With the 35–135mm f/3.5–4.5 lens, for instance, as the lens is zoomed from its minimum focal length (35mm) to its maximum focal length (135mm), the effective aperture is gradually reduced by approximately one full stop.

In programmed or autoexposure modes, this reduction of the aperture size will not cause exposure problems; the camera's shutter speed is automatically adjusted to compensate for the decrease in transmitted light. Even in TTL flash photography, exposures remain correct. This is because the flash exposure is metered off the film, so the flash duration is automatically adjusted for any decrease in light.

But, perhaps you are not able to use TTL flash, such as in a studio situation using multiple flashes. TTL metering is not possible because the studio flash units are not "dedicated" TTL flashes. In

this situation, flash exposures could be off by up to one f/stop unless you recognize the problem and compensate for it manually.

Minolta Maxxum Autofocus Lenses

The Maxxum autofocus lens system is of one of the world's largest families of autofocus lenses. The prime AF lenses range from a 16mm f/2.8 fisheye to a 600mm f/4 Apo telephoto. Minolta also offers many versatile zoom AF lenses. The newer zoom lenses in this extensive selection feature advanced optical designs for excellent image quality combined with far faster autofocusing than was possible on the original series of Maxxum cameras. Many of the newer optics having the "Apo G" moniker incorporate advanced optical technology in their design and feature a larger maximum aperture, which combine to produce high-performance lenses for making superior quality images. Also available are 1.4x and 2x teleconverter lenses for use exclusively with the prime AF Apo G lenses.

Minolta is constantly upgrading and improving their AF lenses. Although some lenses (particularly in the zoom family) have the same focal length, they differ slightly in maximum lens speed, weight, and/or size. Some of the size and weight reductions in the newer optics are quite impressive. Since you will often be looking for additional used equipment for your Minolta camera, knowing the different lenses available should be of valuable assistance when making a decision as to which lens you should try to locate and which will best suit your particular requirements.

Maxxum AF Normal Lenses
The 50mm lens has long been considered the workhorse lens in the industry, however it has recently fallen in popularity. The Maxxum AF 50mm f/1.4 offers an extremely fast maximum speed and is eminently suitable for photographing in existing light without the need for supplementary flash. With the fast films available today, the Maxxum AF 50mm f/1.7 is more than adequate for most subjects today as it is less expensive than the f/1.4 while still considered fast at its maximum aperture. Generally a bargain in used equipment cases, it is also 1-1/2 to 2 full stops faster than most zoom lenses that include the 50mm focal length.

Some photographers opt for a 50mm f/2.8 macro lens so they will have a lens that offers close-up focusing capabilities and is also suitable for general photography. Others choose a wide to

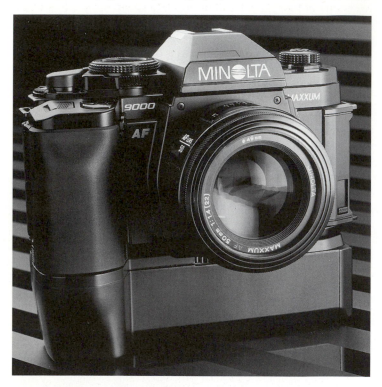

The Maxxum AF 50mm f/1.4 lens features an ultra-fast maximum aperture especially suitable for existing light and low light level photography.

Optical construction: 7 elements in 6 groups
Angle of view: 47°
Minimum focus: 1.5 ft. (0.45 m)
Aperture range: f/1.4 to f/22
Filter diameter: 49mm
Dimensions: 2-9/16 x 1-1/2 in. (65 x 38 mm)
Weight: 8-5/16 oz. (235 g)
Other: Built-in lens shade

moderate telephoto zoom lens that includes the 50mm focal length among its many possibilities. The fact that the zoom lens has a maximum aperture of f/3.5 or even f/4 is of little hindrance when one of today's fast 200 or 400 ISO speed films is loaded in the camera.

Maxxum AF Macro Lenses

Minolta offers several macro lenses (50mm and 100mm) in the Maxxum system that will autofocus automatically from infinity continuously down to 1:1 (life-size) without interruption or the need for adapters. Magnification ratios are marked on the focusing ring of the 50mm and 100mm macro lenses should you need to record this information for later reference.

The 50mm macro lens was about three inches away to get this detailed look into a model's eye. A 100mm macro lens would have allowed the camera to be less intrusive at six inches away. Note the very shallow depth of field typical at such a close distance.

The Maxxum AF 50mm f/2.8 Macro lens would be the logical choice for an individual that does a lot of extreme close-up photography of small objects. However for nature subjects, the Maxxum AF 100mm f/2.8 Macro lens is preferable because of the greater working distance it offers between lens and subject. Its minimum focus is 13.6 inches (34.5 cm) and allows you about twice the lens-to-subject distance afforded by the 50mm macro lens. This lens also has a very convenient limit lock switch on its left side that permits the photographer to limit the range of focus in order to autofocus more quickly on subjects within a specific distance from the lens. But since it has an extra-long helical mount to permit this wide focusing range, the lens will frequently have to autofocus throughout the entire range before it finds the proper focus point. This can become both time-consuming and somewhat frustrating, especially if you are photographing an insect or bug that might be moving, making timing crucial.

The Maxxum AF Macro Zoom 3x–1x f/1.7–2.8 is a the only lens of its kind, designed specifically for extreme close-ups in a very limited high-magnification range. It is only usable in a range from 1x to 3x (that is, life-size to three times life-size), and is usually

The Maxxum AF Macro Zoom 3x–1x f/1.7–2.8 is the only lens of its kind, designed to shoot extremely close subjects in a very limited high-magnification range. It is supplied with an exclusive macro tripod stand that positions the camera-lens unit above the subject, much like a microscope setup. It can be used with the Minolta Macro Flash 1200AF to illuminate the small subject area.

Focal length: 45–52mm
Optical construction: 7 elements in 5 groups
Aperture range: f/1.7–16 (3x) to f/2.8–27 (1x)
Working distance: 1 in. (3x) to 1.6 in. (1x) (25.1 to 40.1 mm)
Power: 6v lithium battery
Camera rotation: 135°
Filter diameter: 46mm
Dimensions: 3-3/8 x 4-5/8 x 3-3/4 in. (85.5 x 117.5 x 95.5 mm)
Weight: 38-13/16 oz. or 2.43 lbs. (1102 g), without battery

not suitable for everyday, conventional photography. Autofocusing is accomplished internally, so the general positions of the subject, lens, and camera body will remain constant, a definite advantage for high-magnification photography. Manual focus is possible using a focusing knob that moves both lens and camera together on a focusing rail. A motorized framing control manipulates the camera's position, facilitating the subject's framing. The camera body can be rotated effortlessly to obtain the desired framing position between horizontal and vertical compositions. Power is supplied by a 6v lithium battery housed in the lens itself.

Either autoexposure or manual exposure can be used with this lens. In autoexposure mode, the Maxxum camera automatically compensates for the reduced light transmission at high magnifications, eliminating the need for extra calculations.

Using a 24mm wide-angle lens to photograph the New York City skyline from under the Brooklyn Bridge places more emphasis on the bridge and less on the tall buildings in the distance.

This lens is supplied with an exclusive macro tripod stand that positions the camera-lens unit above the subject, much like a microscope setup. It can be used with the Minolta Macro Flash 1200AF attached to the front of the lens to illuminate the extremely small subject area.

Maxxum AF Wide-Angle Lenses

Minolta makes many wide-angle AF lenses. You would use a lens like the Maxxum AF 28mm f/2.8 to shoot an entire room in one photograph, a dramatic vista of a scenic landscape, or to fit more people into a group shot. In recent years, as environmental portraiture has become more popular, wide-angle lenses have been used increasingly to create striking portraits of people in their surroundings, traditionally recorded with moderate or short telephoto lenses.

The most extreme wide-angle lens, the Maxxum AF 16mm f/2.8 fisheye, with a 180° angle of view, produces an image with considerable distortion, which can be used to dramatic effect.

Maxxum AF Telephoto Lenses

The Maxxum 300mm f/2.8 Apo and 600mm f/4 Apo have considerably faster maximum speeds than most lenses available today with similar focal lengths. This makes them a particular favorite for making sports and wildlife photographs. All apochromatic lenses have better optical correction than other long telephoto lenses, so they command a higher price.

As mentioned before, the general rule-of-thumb for hand-holding any telephoto lens is to use a shutter speed that is at least equivalent to the reciprocal of the focal length of the lens. The greater size, length, and weight of a telephoto lens makes it more difficult to hold the camera steady, and the effects of camera shake are amplified by long lenses. The Maxxum series' Automatic Multi-Program Selection feature takes this into consideration and will automatically select a faster shutter speed that corresponds to the focal length of the telephoto lens (or zoom lens used at its telephoto setting) attached to the camera.

The Maxxum AF Reflex 500mm f/8 is a mirror lens. Very lightweight and maneuverable, it features a fixed f/8 aperture with a built-in ND (Neutral Density) filter for when less exposure is desired. It can be operated in either autofocus or manual focus mode with the 8000i, 7000i, or 5000i cameras. With other Maxxum cameras, only manual focus mode is possible.

Optical construction: 7 elements in 5 groups
Angle of view: 5°
Minimum focus: 13 ft. (4.0 m)
Aperture range: f/8 only
Filter diameter: Integral
Dimensions: 3-1/8 x 4-5/8 in. (89 x 118 mm)
Weight: 23-7/16 oz. (665 g)
Other: Lens hood furnished

Maxxum AF Zoom Lenses

A Maxxum zoom lens will automatically change your Maxxum camera's program selection as you zoom the lens from wide angle to telephoto and back again to select the shutter speed-aperture combination that is most suitable for the focal length in use. If a

Note the donut-like circles in the highlights in the background. This typically happens when a bright, out-of-focus object positioned behind an in-focus subject is photographed with a mirror lens such as the Maxxum AF Reflex 500mm f/8.

Maxxum flash is being used, the flash head will also automatically zoom in or out to provide the coverage needed by the focal length of the lens for more efficient and even lighting across the image area. The newer "xi" zoom lenses have an internal zoom motor and microcomputer that provide power zooming plus other automatic zoom functions, *but only when used with the newer "xi" and "si" series of Maxxum camera bodies.* (See Caution statement on page 169.)

Maxxum AF Zoom "xi" Lenses
The newer "xi" series of Maxxum zoom lenses are relatively easy to distinguish from earlier Maxxum zoom lenses. They do not have a distance scale under a transparent window, they have "Zoom

xi" imprinted on the body, and the rubberized knurling on the lens that is grasped to activate the power zoom function (on "xi" and "si" bodies only) is wider and has been relocated to the front of the lens.

This same wide, knurled, zoom control ring is also used to focus manually. After switching the camera focus mode switch to "M," you simply pull the knurled zoom ring back toward the camera body, and turn it to the right or left to activate power manual focus.

A convenient focus-hold button, located on the side of several of the new, longer zoom lenses, will instantly lock the focus when depressed. This is quite an asset for sports and other fast-action photography.

Caution: *The Maxxum zoom lenses with "xi" as a suffix are intended primarily for use with the latest Maxxum "xi" or "si" cameras, which include power zoom functions. While these newer lenses will all autofocus correctly when mounted on the original 3000, 5000, 7000, and 9000 cameras and second-generation 3000i, 5000i, 7000i, and 8000i cameras, the zoom mechanism must be operated manually. Manual focus is not possible with these lenses when mounted on earlier Maxxum cameras. Because the focus point changes with the focal length, the AF Zoom xi 28–80mm f/4–5.6 lens must be refocused after zooming, therefore it cannot be used on any of the two early series of Maxxum bodies. In general, it would be wise to purchase any of the older Maxxum lenses (rather than the new "xi" zoom lenses) to use with older camera bodies.*

Note: To zoom the Maxxum AF Zoom xi 100–300mm f/4.5–5.6 Macro lens manually with any of the first two series of Maxxum bodies, set the AZ/MZ switch to "MZ," then turn the rubber ring normally used to zoom the lens.

Maxxum AF Teleconverters
In addition to the prime and zoom Minolta AF lenses, Minolta makes teleconverter lenses that are used to extend the focal length of a telephoto lens. The 1.4x and 2x teleconverter lenses can be used only with the Maxxum AF Apo G lenses. To emphasize their family affiliation, the teleconverters are white, like the lenses with which they are compatible.

Caution: Use of these teleconverters with non-AF Apo G telephoto lenses may result in damage to your equipment.

Maxxum (Dynax) Accessories

Maxxum Flash Units

Minolta manufactured many flash units for use with its Maxxum-series cameras. The following is a brief description of some of these flash units, their features, and camera compatibility. The Maxxum flash units with the AF designation, 1800AF, 2800AF, 4000AF, Macro Flash 1200AF, as well as the Wireless Controller IR-1N Set can be made compatible with "i" series cameras by using the Flash Shoe Adaptor FS-1100 described in this chapter.

Maxxum 1800AF Flash
The Maxxum 1800AF is a low-profile basic shoe-mount flash unit designed for use with the original Maxxum cameras with lenses of 35mm or longer focal lengths. It is simplified for easy operation with little need for adjustment or setting prior to use. There is an AF illuminator beside the flash tube to assist the autofocusing system of the early Maxxum cameras. The AF illuminator has an effective range of 3.3 to 15 feet (1 to 4.5 m).

This flash unit is unique in one major way: it can be powered by either a single 6v lithium battery or by four AAA-size alkaline batteries. As with any older model flash unit, be sure to check the terminals when changing batteries and wipe them with a clean, dry cloth or a pencil eraser prior to reinstalling fresh batteries.

1800AF Operation: To mount the 1800AF, turn the power off and move the mounting clamp on the base to the right. Slide the flash unit into the camera's hot shoe then turn the clamp to the left to secure the unit. To remove, switch the power off, loosen the mounting clamp, grasp the base of the flash and slide the flash straight out of the shoe.

In Program ("P") mode with the 5000, 7000, or 9000 cameras, flash photography is totally automatic with no need to make any manual settings. In Manual ("M") mode autoflash is possible with the 5000, 7000, and 9000 cameras. In this mode, both the shutter speed and aperture must be set manually. With the 7000 and 9000

cameras, exposures can also be made in the Aperture Priority ("A") mode, allowing the aperture for the desired depth-of-field. Only the 9000 can be used in Shutter Priority ("S") mode with flash. Any shutter speed from 1/250 second to 30 seconds can be set and used; the aperture will be automatically set to f/5.6.

Maxxum 2800AF Flash
Introduced with the Maxxum 7000, the 2800AF flash is one of the dedicated Maxxum flash units made for the 5000, 7000, and 9000 cameras' conventional hot shoe. It features TTL metering and an AF illuminator. The film speed and exposure settings are received

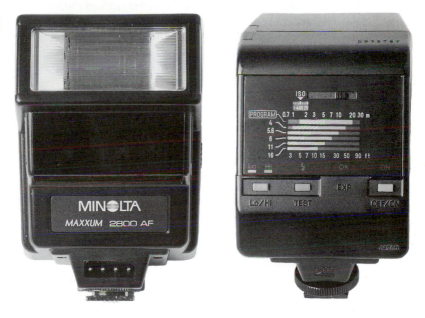

from the camera and set on the flash automatically. (The ISO setting on the back of the flash unit affects only the range scale.) Power is supplied by four AA-size alkaline or rechargeable NiCd batteries.

2800AF Flash Operation: To mount the 2800AF flash, make sure the power is turned off, then turn the mounting clamp on the base

171

fully to the right. Slide the flash unit into the camera's hot shoe, and turn the clamp to the left to secure the unit.

The 2800 AF has two power levels: "Hi" for maximum flash range or "Lo" for faster recycling, which is needed when shooting in continuous drive mode. Colored markings found below each power level correspond to the flash ranges shown on the flash range scales. For example, with ISO 100 film at "Hi" power, the range in Program ("P") mode is 2.3 ft. to 33 ft. (.7 to 10 m); at "Lo" power the range is reduced to a maximum of 8.2 ft. (2.5 m).

Programmed autoflash operation is simple. Set the camera to "P" mode, and press the flash's power switch to turn it on. When the flash is charged, the flash ready signal on the back of the flash unit will glow and the flash signal in the viewfinder will blink. After a picture is made, if the light was sufficient for proper exposure, the flash signal in the viewfinder will blink rapidly and the "OK" signal on the flash unit will glow. Fill-flash exposure is also calculated automatically in "P" mode.

In Aperture Priority ("A") mode, the photographer can select any available aperture to control depth of field and background illumination. The flash unit's range scale displays the minimum and maximum subject-to-flash distance for a given aperture.

In Shutter Priority ("S") mode, autoflash is possible only with the Maxxum 9000. Any shutter speed from 1/250 second to 30 seconds can be set and the aperture will automatically be set to f/5.6. The camera's TTL flash metering will automatically control the exposure.

In Manual ("M") mode, the flash duration is controlled by the camera's direct autoflash metering system, so no calculations are necessary. Any available shutter speed from the camera's highest X-sync speed up to 30 seconds, or "bulb" can be used. In "M" mode, the camera's exposure compensation control can be used to increase or decrease the flash exposure from +4 to -4 f/stops.

Daylight fill flash provided just the proper amount of light to illuminate this cat while he was resting in a tree. Without fill flash, very little detail would have been visible in the shade of the tree.

Maxxum 4000AF Flash

The first full-featured dedicated flash for the original series of Maxxum cameras was model 4000AF. It has a conventional hot shoe, a power zoom head that automatically adjusts the flash coverage for lenses with focal lengths of 28mm through 70mm, a two-way bounce head that pivots 90° upwards and 180° side to side, a built-in AF illuminator, and a respectable Guide Number (GN) of 131 in feet (40 in meters).

4000AF Flash Operation: The 4000 AF operates similarly to the 2800 AF with a few exceptions. The 4000AF has six power levels: FULL, 1/2, 1/4, 1/8, 1/16, and MD (Motor Drive). To set the power level, press the power level selector button (marked "LEVEL"). Each time the button is pressed, the level cycles in the following order: FULL, 1/2, 1/4, 1/8, 1/16, MD, and back to FULL. For maximum flash range, "FULL" power should be set. Any of the other

settings can be used to reduce the recycling time, control the flash range, or save battery power. For shooting sequences illuminated by flash, set the unit to "MD" and it will recycle at up to two fps.

Slow-Speed Sync: Conventional flash pictures under low lighting conditions normally result in properly exposed subjects with very dark backgrounds. Aperture Priority slow-speed sync uses a longer exposure time to allow ambient light to expose the background, while subjects are exposed by the flash. Although metering for slow-speed sync is a bit involved, it can be worth it to capture your subject in front of a well-exposed sunset or with the lights of the big city behind them.

To set slow-speed sync, start with the flash switched off. Choose an aperture that corresponds to a shutter speed of 1/60 second or slower (1/125 second or slower with the Maxxum 9000). Try

experimenting by starting at 1/15 second. Now switch on the flash. When it is charged, the shutter speed will be set to the camera's maximum X-sync speed.

When you press and hold in the AEL button, the shutter speed will be set one stop faster than the metered speed to prevent over-exposing the primary subject. While holding the AEL button in, focus on the subject, determine that it is within the flash range for the aperture selected, and take your picture. If the flash exposure was sufficient, the flash signal in the viewfinder will blink rapidly.

Note: In low light levels, the ambient-light exposure often requires a shutter speed too slow to hand-hold the camera. A tripod is recommended.

Maxxum Macro Flash 1200AF

This unusual small flash is intended primarily for use with the 50mm or 100mm macro lens to illuminate small, close objects, but it can be used with other Maxxum AF zoom and prime lenses in their macro range with the proper adapter ring. Although it has a standard flash shoe contact intended for use with the Maxxum 5000, 7000, and 9000 cameras, it can be used with later model cameras having a split-shoe by using the Flash Shoe Adapter FS-1100.

Four AA-size batteries fit into a compartment on the side of the power unit. Either alkaline or rechargeable NiCd batteries can be used. To conserve battery power, the 1200AF automatically turns itself off if the camera's shutter release is not touched within one minute after being fully charged.

Using the 1200AF: To mount the 1200AF, make sure the power is switched off, then turn the mounting clamp on the base fully to the right. Slide the flash power unit into the camera's hot shoe then turn the clamp to the left to secure the unit. To remove the unit, switch the power off, loosen the mounting clamp, and slide the flash straight out of the shoe.

For TTL direct autoflash metering, the Maxxum 5000 and 7000 can be used with any film of ISO 25 to 1000, the Maxxum 9000 with ISO 12 to 1000. With the Maxxum 5000, use Manual ("M") mode only. With the 7000, use Aperture Priority ("A") or Manual mode.

Check to see that the ISO slide on the back of the power control unit has been set to the desired film speed. The working-range bars on the back of the unit show the apertures suitable for the particular film, magnification ratio, and lens. The blue segment of

the bar applies to the Maxxum AF 50mm f/2.8 macro lens; the beige segment applies to the Maxxum AF 100mm f/2.8 macro lens; the striped segment applies to both lenses.

Four incandescent focus lamps are mounted near the flashtubes to make it easy to frame nearby subjects and to provide light for the camera's autofocusing system. If the focus-lamp switch is on (i.e., the flash-lamp signal is lit) the focus lamps will light when the camera's shutter release button is touched. The lamps will turn off after ten seconds or when the shutter is released to make the picture. They may be turned off manually by pressing and releasing the focus-lamp switch.

Maxxum Dual-Rail Hot Shoe "i" Series Flash Units

Minolta designed an exclusive dual-rail hot shoe for its "i," "xi," and "si" series cameras. The flashes in this section are made

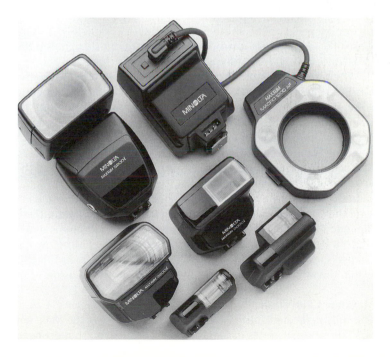

specifically to fit these cameras, however, they can be attached to earlier Maxxum cameras (such as the first-generation 7000 and 9000) by using the Flash Shoe Adapter FS-1200.

Maxxum 2000i Flash

This is a low-profile, lightweight flash suitable for general-purpose photography with any of the "i," "xi," or "si" cameras. To use this flash with earlier Maxxum cameras you'll need to use the Flash Shoe Adapter FS-1200. The 2000i flash is powered by four AA-size batteries and has a GN of 65 in feet with ISO 100 film. Its small size (2-5/8 x 2-7/16 x 3-5/8 in., or 6.67 x 6.19 x 9.21 cm) and light weight (4-15/16 oz., or 140 g, without batteries) make it a great flash unit for travel.

2000i Flash Operation: The easiest way to take flash pictures with the 2000i (or the later similar model, 2000xi) is in "P" mode auto-flash. After pressing the on/off button on the flash, the unit's flash on signal will glow. Wait for the flash ready signal to blink in the camera's viewfinder. When the flash is charged, you can take a picture by pressing the shutter release down completely. If there was sufficient light for a proper exposure, the flash signal in the viewfinder will blink rapidly.

When the flash is on and the camera is set to "A" mode, the flash will fire every time you take a picture. In addition, selecting a large aperture will reduce the flash recycling time so you can take pictures in a more rapid sequence.

When the flash is on and the camera is set to "S" mode, the flash will also fire each time you take a picture, but *both* the shutter speed (which will be set to the proper X-sync speed) and the aperture will be set automatically by the camera.

In "M" mode, as in "A" and "S" modes, the flash will fire each time the shutter is released as long as the flash is fully charged. Operate the camera in the same manner you would in this mode without flash, but be sure to set the shutter speed at or below the camera's fastest X-sync speed. Also check to be sure the subject is within the range of the flash for the film speed you are using.

Maxxum 3200i Flash

This fully dedicated autoflash can be used with any of the Maxxum "i," "xi," and "si" series cameras. The proper X-sync shutter speed

While the camera's meter attempted to provide the proper exposure for this strongly backlit dog, there are too many deep shadows that cover up detail. Look how much better the right-hand view is when the automatic dedicated flash is switched on, providing just the right amount of fill light to illuminate the shadows.

is automatically set when the flash unit is charged. With these cameras, direct TTL/OTF (Through-the-Lens/Off-the-Film) metering is provided based on the camera's film speed setting. There is no need to set anything on the flash, as all communication is conveyed through the camera's internal computer. The flash itself has a built-in AF illuminator with a range from 1.6 to 29.7 ft., or .5 to 9 m, which is automatically triggered in low-contrast, low-light situations.

An internal power-zoom mechanism automatically adjusts the flash head from 28mm to 85mm to correspond with the focal length of the lens in use. This optimizes battery power and ensures complete illumination for the lens' angle of view. For lenses shorter than 28mm the flash head will remain at 28mm and for telephoto lenses longer than 85mm the flash head will remain at 85mm.

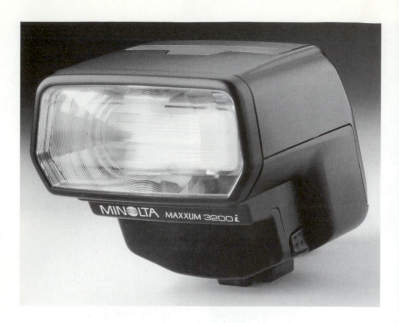

3200i Flash Operation: Minimal controls on the back of the flash unit include an on/off button and a power level selector. Indicators include "AUTO" program mode, flash "ON/OFF," flash ready, and "Lo" power level. When the 3200i is attached to a Maxxum camera operating in "P" mode, there is no need to manually switch on the strobe itself. The flash command system in the camera switches the flash on whenever necessary. If the camera is not tripped by the shutter release button for about 5 seconds, the flash unit is automatically switched off to conserve the batteries. Charging is restarted by lightly pressing the shutter release button.

Maxxum 5200i Flash

The feature-laden Maxxum 5200i flash was introduced with the Maxxum 8000i camera. At the time, it offered several innovations in the Maxxum system: the first dedicated strobe with a powerful Guide Number of 171 in feet (with ISO 100 film), ratio control lighting for multiple flashes, and a tilt and swivel feature. This strobe is super-intelligent with advanced capabilities found on few other hot-shoe flash units. It has a simplified LCD display panel

with a menu for selecting the desired operations by those who want more than just a high-powered, totally automatic flash unit.

5200i Flash Operation: This intelligent unit keeps the need for operator calculations to the bare minimum. In its TTL automatic mode (with the camera set for "P," Programmed Automatic) all you have to do is switch it on. The camera automatically adjusts to the proper sync speed (1/200 second on the 8000i camera), and the lens adjusts to the proper aperture.

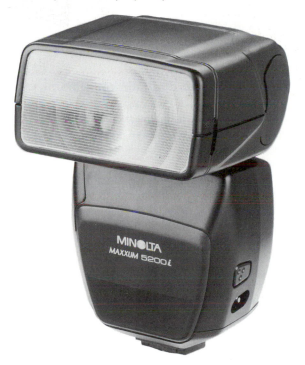

As you change the focal length of a zoom lens (prior to partially pressing in the shutter release button to make an autofocus distance measurement) the power-zoom flash head is automatically adjusted to match the lens' focal length between 24mm and 85mm.

A full-information LCD panel on the back of the flash provides legible information that details the flash's settings. It indicates when

the flash is in AUTO or TTL mode, the distance range (which can be adjusted to read in either feet or meters) within which a proper exposure can be made, the focal length at which the flash is adjusted, and the output level ranging from 1/1 to 1/32 power.

Maxxum Flash Ratio Control: If two or three similar models of Maxxum flashes are linked by accessory cables, you can control the flash output from each unit in either a 1:2 or 2:1 ratio to create more pleasing lighting on the subject.

The flash's power level can be varied in six steps from full output (1:1) down to 1/32 output. At lower power levels, the flash will recycle faster so pictures can be made more quickly. At the higher power levels, the light is brighter and will carry out to greater distances. This is shown visibly on the LCD panel of the 5200i, along with automatic adjustments in the distance range.

Stroboscopic Flash: An unusual feature of 5200i is the multi-flash mode, which fires repeated flash bursts on a single frame of film. It produces a stroboscopic effect and is useful for studies of moving objects.

Push-button control keys located below the LCD panel on the rear of the strobe's body set the number of flash bursts and their frequency. The flash firing sequence can be selected for any of eight rates between 1 and 50 Hz, while the total number of flash bursts produced can be set in six steps from 2 to 10, or continuous.

Depending upon the frequency (Hz) and the number of bursts of flash you select, the recommended shutter speeds range from 1/15 second up to 15 seconds with the camera set for manual operation. The camera should be mounted on a tripod and the subject should be in front of a dark background.

Other 5200i Capabilities: When you are photographing in a small room with either a white ceiling or wall, you can bounce the 5200i flash off it for softer, more diffused lighting. The exposure is measured TTL/ OTF in bounce mode, and the confirmation signal will blink, indicating that the light was adequate for proper exposure. However, the operating distance range on the flash's LCD panel will be blank because the flash cannot pre-determine the actual distance of the bounce surface or the resulting loss of light.

Like most of the other Maxxum flashes, there is a built-in AF

illuminator on the front of the 5200i that is automatically activated in dim light or completely dark situations. It projects a line pattern up to 30 feet (9 m) away as a target for the camera's auto-focusing system.

When you make a fill-flash exposure of a backlit daylight subject or a subject at dusk, the camera will select a proper (high) flash sync speed (1/200 or 1/125 second). This exposure time is generally too brief for the darker background to fully register on film. By pressing the SPOT button on the back of the 8000i's body, the camera will shift to slow-speed sync (selecting a shutter speed appropriate for the prevailing lighting). This will create a more pleasing exposure of the background near the subject. Slow sync may produce a rather slow shutter speed, so brace your elbows on a firm support or use a tripod.

In Manual mode you don't have to interpret a cluttered dial. Once you adjust the camera's shutter speed and lens aperture to what you want (for the desired depth of field), just look at the flash's LCD and read the flash-to-subject distance needed for the correct exposure. This may not be the correct distance; in that case, adjust the aperture to change the recommended distance.

Flash was used to expose the subject, but a slow shutter speed produced the ambient light exposure in the background, as well as the dramatic display of sparks.

Maxxum Flash Accessories

Off-Camera Cable and Shoe for Dual-Rail Flash Units

Although using a Maxxum flash unit on the camera's hot shoe is fast and convenient, this does not necessarily produce the most pleasing lighting. To enable photographers to use flash units off-camera for more creative lighting, Minolta offers several cables. These permit you to use any of their flash units fully dedicated with TTL/OTF light measurements at arm's length or farther away from the camera. Another plus derived from positioning the flash farther away from the lens is red-eye reduction. Glowing red eyes often found in photos of people and pets are less likely to occur when the flash is not located close to the lens.

Off-Camera Cable OC-1100

The Off-Camera Cable OC-1100 is a four-foot long coiled cable used with Off-Camera Shoe OS-1100 and any dual-rail Maxxum flash such as the 2000i, 3200i, or 5200i with any of the Maxxum "i" cameras (3000i, 5000i, 7000i, and 8000i) or the later "xi" or "si" series of cameras. Up to five Cable EX extensions can be connected to enable you to place one flash at a maximum of about 20 feet (6 m) from the camera. You can also use up to three flash units to light one subject by using the Triple Connector TC-1000 accessory.

Full TTL/OTF control of the flash-duration and exposure confirmation signals are maintained with these connecting cords, thus retaining the convenience of automatic flash operation. The only feature that is disabled is the AF illuminator (if any exists) on the flash unit.

To use the Off-Camera Cable OC-1100, slide the mounting foot into the camera's hot shoe until it clicks into place. Align the guide on the plug of the cable OC-1100 with the guide on the socket of

A simple, fully automatic flash exposure can produce far more detail ⇨
and interesting shadows on your subject's face when the dedicated flash
unit is held at arm's length above and to the left of the camera.

the Off-Camera Shoe OS-1100. Push the plug fully into the socket and secure it by tightening the outer ring locking device. Now the flash unit can be held at arm's length from the camera or fastened to a flash bracket or tripod using the 1/4"-20 threaded socket in the camera's base.

Flash Shoe Adapter FS-1100
The Flash Shoe Adapter FS-1100 allows flash units with conventional "feet" to be mounted on Maxxum cameras that have the Minolta-specific dual-rail flash shoe. The FS-1100 features a small foot that has a male dual-rail contact on its base, which slides into the "i," "xi," and "si" camera series hot shoe. It also has a hot shoe on top, into which one of the early model Maxxum flash units will fit. This permits you to use older Maxxum flash units (models 1800AF, 2800AF, 4000AF, Macro Flash 1200AF) with the second-generation Maxxum cameras such as the 7000i and 9000i. However, since the conventional foot flash units have a "hard" on/off switch, they must be turned on manually whenever flash is required. The flash will not switch itself on whenever the camera senses additional light is needed.

Flash Shoe Adapter FS-1200
This adapter allows cameras with conventional hot shoes (such as the Maxxum 7000 and 9000) to accept newer Minolta flash units featuring the Minolta-specific dual-rail flash foot.

Maxxum Remote Cords
If you want to fire a Maxxum 5000, 7000, 9000, 5000i, 7000i, or 8000i camera from a distance or trigger a tripod-mounted camera without creating vibration, a remote cord is a useful accessory. Remote cords RC-1000S (20 in., or .5 m long) and RC-1000L (16.5 ft., or 5 m long) have an electrical contact plug on one end that fits the camera body contact. The remote cord's hand unit has a small compartment for storing this tiny terminal cover until you want to replace it.

A single flash unit on a long dedicated extension cord was positioned on a stand behind the large leaf. The one flash provided strong backlighting, which vividly outlined the leaf edges on this fully automatic exposure. ⇨

Once the cord is connected, press lightly on the remote unit's release button to activate the camera's autofocus and metering systems. Then press the button all the way down to actually trip the shutter and make the exposure. If you are making exposures on "B" (bulb) and want the shutter to stay open, press the remote release button in; then slide it in the direction indicated by the arrow to lock the shutter open. To close the shutter, slide the button back again and lift your finger.

Maxxum Control Grip CG-1000

The Minolta Control Grip CG-1000 is a handle for use with the Maxxum 7000, 9000, 7000i, and 8000i cameras. At the top of the grip is placed a Maxxum flash 4000AF, 2800AF, or Macro Flash 1200AF. A base unit camera bracket is attached to the bottom of the camera. Now the grip can be directly attached to the bracket, or an intermediate connecting cord can be used to provide the continuity between the grip-flash unit combination and the camera for off-camera flash techniques.

The CG-1000 accepts six AA-size batteries that will extend the life of the batteries in the flash unit and recycle the flash unit faster for more rapid picture-taking, especially when the flash is used with a motor drive.

AF Illuminator: The built-in AF illuminator on the 2800AF and 4000AF flash units will not operate when mounted onto the grip, so a separate AF illuminator unit is supplied with the CG-1000 set. The auxiliary AF illuminator unit (which requires four AAA-size batteries) mounts on the camera's accessory shoe to enable autofocusing with the flash mounted on the control grip. The AF illuminator unit is necessary only with the 7000 and 9000 cameras, since the 7000i and 8000i cameras have a built-in AF illuminator.

Maxxum 7000 Accessories

Focusing Screens

Four user-changeable Model 70 focusing screens fit the Maxxum 7000. Type G is the standard screen with the focus frame centered in a matte field; Type L has a matte field with a grid that is helpful for architectural photography; Type S has vertical and horizontal

scales helpful for macro-, micro-, and astrophotography; Type PM has a split-image/microprism/matte field with the autofocus zone along the split image. Tweezers were supplied with the focusing screens by the manufacturer for easy installation. It is important that you not touch the screens with your bare hands so as to avoid damaging them.

Maxxum Data Back 70
This back provides the capability of imprinting the time or date onto the film. Several printing choices, plus a no-printing option, are offered.

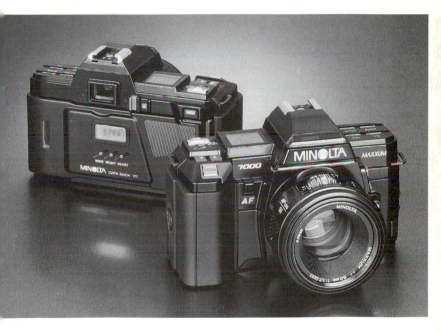

Maxxum Program Back 70
The Program Back 70 automatically imprints the date, sequential frame numbers, or a coded six-digit numerical sequence onto the film. The imprint exposure level is governed by the film speed in use. The PB 70 can also be used to control the camera's start time, interval of exposure, and the number of frames to be exposed.

Maxxum Program Back Super 70

This replacement back includes all of the features found in the Maxxum Program Back 70, as well as several additional capabilities such as a special memory that allows you to create your own exposure programs for recall at any time, and automatic bracketing for up to nine consecutive exposures set in quarter-stop intervals. The exposure data for the aperture and shutter speed that is actually used to make each exposure can be imprinted on the extreme edge of the film frame (the area normally masked by slide mounts or cropped when prints are made).

Maxxum 9000 Accessories

Focusing Screens

The five Model 90 screens for the Maxxum 9000 are not compatible with the Maxxum 7000. Four screens, types G, L, S, and PM, are similar to the four Model 70 screens, except they also have a central circle indicating the spot metering field. The fifth is Type C, similar to the Type G standard screen except that visual focusing is not possible. You can quickly replace these screens using the tweezers supplied by the manufacturer. Be careful not to touch the screens with your bare hands as damage to the screens could result.

Maxxum Motor Drive MD-90

Both winding and rewinding the Maxxum 9000 can be powered by adding the Motor Drive MD-90, which is powered by 12 AA-size batteries. An optional NiCd battery pack NP-90M comes with the NC-90M charging unit. The MD-90 weighs 11 oz. (312 g) without batteries.

A switch on the back of the motor drive sets the operating mode. Release Priority autofocus with continuous drive lets the photographer move with the subject and records up to 5 fps. In this mode you have the options of single-frame operation ("S"), 2 fps film advance ("L"), 3 fps film advance ("M"), or continuous firing and advance at 5 fps ("H"). In Release Priority mode the shutter can be tripped at any time even if focus has not been confirmed. Focus Priority autofocus motor drive offers up to 4 fps film advance. In Focus Priority mode the shutter will not fire until the autofocus

mechanism confirms proper focus. The motor drive can also be set at Manual ("M") when manual film advance is desired.

The MD-90 has a shutter release button on the side of the battery pack to allow you to more easily operate the camera in a vertical position. To make horizontal pictures, use the camera's standard shutter release.

At the end of the roll the motor automatically shuts off. Sliding a switch and pressing a button initiates the film rewind, leaving the film leader protruding out of the cassette.

Auto Winder AW-90

This accessory attaches to the camera base, coupling continuous film advance to the autofocus system. A micro motor operates the camera's film advance shutter-cocking mechanism after each exposure. One of two film advance rates can be selected by sliding a switch to "S" (Single-frame) advance or "C" (Continuous) at up to 2 fps. Manual film advance (using the camera's film advance lever) is possible when the selector dial is set to "OFF." At each setting, focus priority shutter release can be selected. All exposure modes are usable. It is powered by four AA-size batteries and weighs 11-1/8 oz. (315 g) without batteries.

Maxxum Program Back Super 90

Probably the most interesting accessory for the Maxxum 9000 is the Program Back Super 90 with a built-in microcomputer for creating individualized exposure programs. Professional photographers or those engaged in scientific or technical research would welcome these capabilities.

User-adjustable programs for automatic exposure bracketing of up to nine frames are possible with either quarter-, half-, one-, or two-stop exposure changes. This can be done in either Shutter Priority, Aperture Priority, or Manual mode. In Manual Long-Time ("LT") mode, exposure times from 10 seconds to 2 hours 45 minutes are available in 10-second increments. This LT mode can be combined with the intervalometer for long exposures at preset intervals.

This program back can store up to eight spot-metered readings in memory. An intervalometer function can delay the operation of the camera for up to a month—even with the flash unit (which is automatically turned on and off) attached. Five types of data

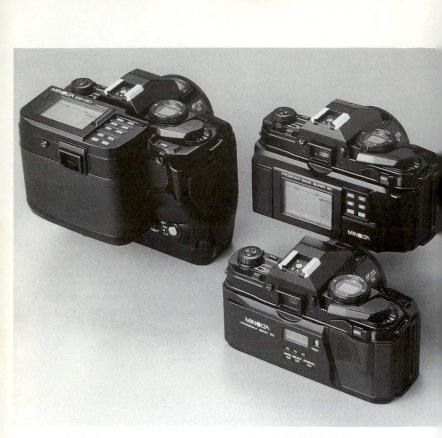

(Clockwise from left) The Maxxum 100-Exposure Back EB-90, Program Back Super 90, and Program Back 90 fit only the Maxxum 9000 camera.

(exposure data, date, time, count up, or count down numbers) or a fixed set of coded numbers can be imprinted on the film using this versatile accessory.

Maxxum 100-Exposure Back EB-90

The 100-Exposure Back EB-90, for use with long rolls of film, permits exposure of up to 100 frames. It has its own built-in motor drive advance and incorporates a Program Back Super 90, so it can be used for time-lapse studies with precise documentation offered by the data imprinting function. Film is loaded into special plastic film cassettes by using the film loader FL-90.

Maxxum 7000i and 8000i Accessories

Focusing Screens

Three user-changeable Model 7 focusing screens are made for the 7000i and 8000i cameras. The Type G screen is standard; Type L has a grid pattern on a matte field; and Type S has vertical and horizontal scales. The wide, center, and spot metering focus areas are marked on each of these screens.

Maxxum Program Back PB-7

The Maxxum Program Back PB-7, which replaces the normal camera back, fits only the 7000i and 8000i models and offers you the choice of six different imprint modes that record data directly onto the lower right corner of the film frame. A quartz clock and automatic calendar allows the imprinting of time and date information. Other imprint modes can be selected to imprint either sequential numbers or a fixed number of your choosing. Imprinting can be canceled at any time simply by pressing a key.

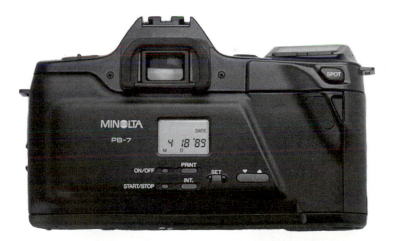

In addition, the PB-7 allows the photographer to program camera operations using intervalometer and long exposure functions. The start time, interval time, and the number of exposures desired can be entered to set the 7000i or 8000i for unassisted operation.

The camera's autofocus and autoflash functions are fully compatible with the PB-7. It is possible to program time exposures of up to ten hours. The intervalometer and long exposure functions may be used separately or in combination with one another.

Maxxum Data Back DB-3/5/7
The DB-3/5/7 fits all of the "i" series Maxxums and performs all of the imprinting functions that the PB-7 can. However it does not offer the intervalometer and long exposure functions.

Maxxum Panorama Adapter Set
Shortly after the 7000i and 8000i cameras were first marketed, Minolta introduced a Panorama Adapter set—a masking adapter for the film plane and a focusing screen mask, both easy to install with the tools supplied. The Panorama Adapter is suitable for many subjects like scenic landscapes, tall buildings, cityscapes, or group portraits. Some close-up, macro shots may be enhanced by using this unusual format.

The mask has an opening to produce an elongated 13 x 36 mm image in the center of a standard 24 x 36 mm frame area. An interchangeable focusing screen that clearly delineates the panoramic image's edge without interfering with focusing and metering is also provided.

All Maxxum lenses and accessories can be used with the Panorama Adapter without any adjustments. All of the viewfinder displays are still clearly visible in the viewfinder. It is most effective when used with an ultra-wide angle lens such as the 20mm or 24mm lenses.

Be sure to tell your photofinishing lab that the film was exposed as panoramics so that they will be printed correctly!

Maxxum Accessory Compatibility

Accessory	Original Series	Series "i"	Series "xi"	700si
Anglefinder Vn	Yes	Yes	Yes	Yes
Magnifier Vn	Yes	Yes	Yes	Yes
Focusing Screen 7	N/A	Yes**	No	No
Eyepiece Corrector 1000	Yes	Yes	Yes	Yes
Circular Polarizer	Yes	Yes	Yes	Yes
Panorama Adapter	No	Yes**	Yes	Yes
Control Grip CG-1000	Yes	Yes**	No	No
Data Receiver DR-1000	Yes	Yes**	No	No
Data Back OD-7	No	No	Yes	No
Data Backs DB-3/5/7	No	Yes	No	No
Program Back PB-7	No	Yes**	No	No
Program Back 70/90	Yes	No	No	No
Program Back Super 70/90	Yes	No	No	No
Teleholder	Yes	Yes	Yes	Yes
Shoe OS-1100	No	Yes	Yes	Yes

Accessory	Original Series	Series "i"	Series "xi"	700si
Cable OC-1100	No	Yes	Yes	Yes
Cable EX	Yes	Yes	Yes	Yes
Cable CD	Yes	Yes	Yes	Yes
Triple Connector TC-1000	Yes	Yes	Yes	Yes
Remote Cord RC-1000 S/L	Yes	Yes*	Yes	Yes
Wireless Controller IR-1N	Yes	Yes*	Yes	Yes

* Do not use with Maxxum 3000i
** Do not use with Maxxum 3000i or 5000i

Minolta's Creative Expansion Card System

The 7000i was the first model in the Maxxum (Dynax) series of cameras to incorporate a system to alter the camera's internal computerized programming. These small, postage-stamp sized cards, called Creative Expansion Cards, are actually miniature software programs with self-contained memory. By adding this totally unique card feature, the designers were able to offer photographers a considerable array of additional capabilities.

The Maxxum 7000i and 8000i cameras accept the majority of the Creative Expansion Cards. The card in use can be seen through a window in the camera's card door.

Note: Please refer to the Creative Expansion Card compatibility chart at the end of this book to determine which cards are suitable for your Maxxum camera.

Inserting the Creative Expansion Card

1. Set the camera's main power switch to "ON" or))).
2. Open the card door.
3. Insert the card with the contacts facing you into the slot at the top of the door. *Never touch the contacts on the front of the card.* The camera's LCD panel will display "CARD."
4. Close the card door.
5. To change and store the card's settings, open the card door and press the "card adjust" button.
6. To cancel the function of the card while it is inserted, press the "on/off" key inside the card door. The boxed "card in use" indicator on the LCD panel will disappear.
5. To remove the card, simply push the card-eject slide up and pull out the card, being careful not to touch the contacts. Store cards in a dry, dust-free location.

The camera's LCD panel contains all of the visible information about setting and using any Creative Expansion Card. When information on the data panel is blinking, adjustments can be made to the card settings. The camera will not fire until adjustments are made and the data ceases to blink.

Most adjustments are made by moving the up/down control button in front of the shutter release. If no adjustments are made for 20 seconds, the camera will revert to its normal settings. After making adjustments, you can store them on the card by pressing the "card adjust" button inside the card door. While the card is in its slot, you can cut off its function by pressing the "CARD" button on the camera just below the LCD panel.

Automatic Depth Control Card: This card adjusts depth of field automatically to provide the maximum range of sharpness for the scene being photographed and the lens in use. It is especially useful for travel photography when photographing landscapes and scenics.

Automatic Program Shift Card: This unusual card permits you to automatically expose a three-frame series with a preset program shift occurring between each frame. The programmed shutter-aperture combination is varied without any change in the exposure. The degree of shift can be set to 1, 2, or 3 stops. All three

exposures will be identical, however the shutter speed will vary, so motion can be frozen in one frame and progressively blurred in the next two frames. The aperture will vary, increasing depth of field. This is an entirely different concept than the effect achieved by the Exposure Bracketing Card, which varies the exposure on each frame.

Automatic Program Shift Card 2: This updated card works with the Maxxum 7000i and 8000i cameras. Operation and features are very similar to those of the original Automatic Program Shift Card.

Close-up Card: With this card it is possible to control the aperture setting to obtain optimum depth of field for all close-up and macro photos. At higher magnifications, the lens aperture closes down more to increase depth of field to record small details sharply. The aperture is adjusted according to the magnification of the subject with a corresponding adjustment in the shutter speed to maintain the proper exposure.

Customized Function Card: The original version of the Customized Function Card was intended for use with the 7000i and 8000i cameras. It permits you to reprogram certain camera functions according to your personal preferences or style of photography.

You can: 1) Select exposure modes; 2) Reprogram the focus-hold button on the 70–210mm and 100–300mm zoom lenses to hold focus, select center-area focusing, or select continuous auto-focusing; 3) Shutter speeds in Manual and Shutter Priority modes can be selectable in one or one-half EV steps; 4) Cancel slow shutter speed audible warning alarm (in Program and Aperture Priority modes); 5) Adjust the film counter to count additively or count down the frames remaining; 6) Set the film rewind to start automatically or manually; 7) Rewind the film leader into the cassette completely (as it normally is) or leave it protruding from the cassette.

Once reprogrammed, the camera will continue to operate in the manner selected, even after the card is removed.

Note: The newer Customized Function Card xi was designed for use with the Maxxum 7xi, 9xi, and 700si cameras. It will not function with the 7000i or 8000i cameras.

Data Memory Card: This card retains complete exposure data for up to 40 exposures. Exposure mode, shutter speed, aperture, lens focal length, lens maximum aperture, and exposure adjustment are all recorded. Data can be recalled frame by frame when you want to check the setting used for any particular exposure. For anyone needing to keep a total record of their exposures for any reason, this card can save lots of tedious note taking. If you must expose several rolls of film at any one time and keep extensive records of each exposure, it would be handy to have several of these cards on hand.

Data Memory Card 2: This card has a greatly extended memory capability over the first Data Memory Card, so it can store the exposure and setting information for up to four 40-exposure rolls of film on the later "xi" and "si" model cameras. However, data for only one roll can be recorded with the 7000i and 8000i cameras.

Exposure Bracketing Card: With this card you can easily bracket the exposure given to a series of frames. This technique is useful when a particularly difficult subject must have one perfect exposure. It is possible to adjust the card's preset change in exposure to suit your preference and situation. You can adjust it to expose a series of three, five, or seven frames with third-, half-, or full-stop changes between each frame.

Exposure Bracketing Card 2: This card, compatible with the 7000i and 8000i cameras, combines exposure bracketing and flash bracketing into one card for a series of three, five, or seven frames in any exposure mode. The flash bracket exposure range is limited to one-half or one full stop. Any built-in flash (such as on the 5xi, 7xi, 9xi cameras) will automatically switch on. For automatic bracketing, the card can be used with a studio or other non-dedicated flash unit attached through the PC terminal in "M" mode only. It will not operate automatically with non-dedicated flash units in other modes.

Fantasy Effect Card: This card is for the creative person that wants to produce soft, diffused, zoom-like effects by automatically changing the focus during a longer exposure. It creates a misty,

soft-focus effect for striking results and can also be used effectively with fill flash. Portraits are particularly suited to this effect, but remember it will impart a fantasy effect on all elements in the frame.

Fantasy Effect Card 2: This new card was introduced with the 7xi and 9xi cameras but is also compatible with the Maxxum 7000i and 8000i. It offers two exposure modes that let the camera either select which method is appropriate for the prevailing light level or use a new double-exposure method. The effects produced by this card can be accentuated by using a telephoto lens at its widest aperture or a macro lens with a wider focusing range.

Flash Bracketing Card: With this card the camera will automatically bracket a series of three, five, or seven flash pictures that will differ by a variable exposure range change of one-half or one full stop. Many photographers who absolutely must capture any one picture perfectly will bracket their flash exposures manually; with this card, it can be done totally automatically. The Data Receiver DR-1000 cannot be used with the Flash Bracketing Card.

Highlight/Shadow Control Card: With this card the camera will adjust the exposure to reproduce highlight and shadow areas more accurately. It increases highlight exposure by 2.3 stops (for a bright rendition), and decreases shadow exposures by 2.7 stops (for a dark rendition).

Multiple Exposure Card: Multiple exposures of certain subjects having the proper background can be creative and striking. Up to nine separate exposures can be made on a single frame of film using any of three selectable modes: normal ("ME-N"), fade-in ("ME-1"), and fade-out ("ME-0"). This card is intended primarily for use with the Maxxum 8000i and the later "xi" and "si" cameras.

Multi-Spot Memory Card: Up to eight spot exposure measurements can be made of one scene with this card. The camera will then calculate the average exposure from all of these temporarily retained values.

Portrait Card: This card has a program that automatically sets the

camera's aperture and shutter speed to make a subject stand out from its surroundings. (Wide apertures for shallow depth of field are selected with any focal length.)

Sports Action Card: This card has a special high-speed program that maintains a faster shutter speed than usual to consistently freeze sports action or other high-speed subjects. The camera is automatically set to Program mode, but higher shutter speeds are used to minimize blurring caused by subject motion.

Sports Action Card 2: This updated card is compatible with the 7000i and 8000i cameras, however not all features will function.

Travel Card: This card is particularly useful when photographing a person or group in front of a landmark or other scenic vista. It will adjust the depth of field to provide the maximum range of sharpness for the scene. Not all of this card's features are functional if used with the 7000i and 8000i cameras.

Expansion Card Cases I and II: The Creative Expansion Cards are only about the size of a postage stamp, but a bit thicker, so they are easy to misplace. Minolta offers a couple of handy accessories for anyone who owns several of these cards. A stiff black plastic Card Case I (Minolta #6930-600), about the size of a credit card, holds three cards and is easy to carry. The slightly larger soft folding Card Case II (Minolta #6930-610) holds up to nine cards. The larger case, which can be attached to the camera's neck strap, is a very convenient way to store extra Creative Expansion Cards and keep them readily accessible while traveling about.

Creative Expansion Card Compatibility

Note: Original series Maxxum 3000, 5000, 7000, and 9000 cameras do not accept any cards.

Card	5000i	7000i/8000i	7xi/9xi	700si
A/S Mode	Yes	No	No	No
Auto Depth Control	Yes	Yes	Yes	Yes
Auto Program Shift	No	Yes	Yes	Yes
Auto Program Shift 2	No	Yes	Yes	Yes
Background Priority	No	No	Yes	Yes
Child	No	No	No	Yes
Close-Up	Yes	Yes	Yes	Yes
Customized Function	No	Yes	No	No
Customized Function xi	No	No	Yes	Yes
Data Memory	No	Yes	Yes	Yes
Data Memory 2	No	Yes	Yes	Yes
Exposure Bracketing	No	Yes	Yes	Yes
Exposure Bracketing 2 for Ambient & Flash	No	Yes	Yes	Yes

Card	5000i	7000i/8000i	7xi/9xi	700si
Fantasy Effect	No	Yes	Yes	Yes
Fantasy Effect 2	No	Yes	Yes	Yes
Flash Bracketing	No	Yes	Yes	Yes
Highlight/Shadow	No	Yes	Yes	Yes
Intervalometer	No	No	Yes	Yes
Multiple Exposure	No	No	Yes	Yes
Multi-Spot Memory	No	Yes	Yes	Yes
Panning	No	No	Yes	Yes
Portrait	Yes	Yes	Yes	Yes
Sports Action	Yes	Yes	Yes	Yes
Sports Action 2	Yes	Yes	Yes	Yes
Travel	Limited	Limited	Yes	Yes

Notes

Notes

Notes